WATERCOLOR BASICS:
SHAPE AND LIGHT VALUE

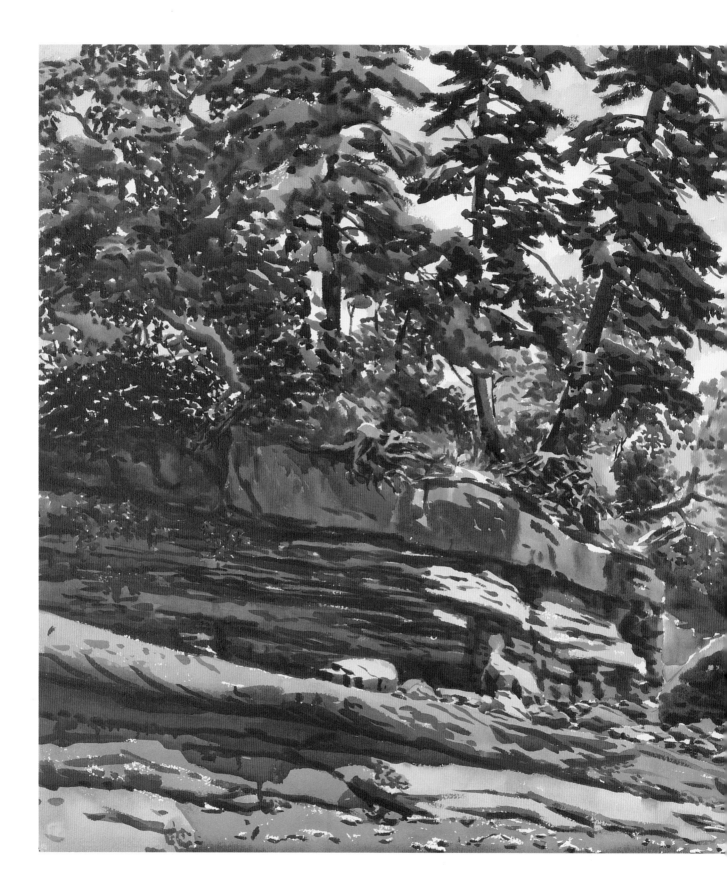

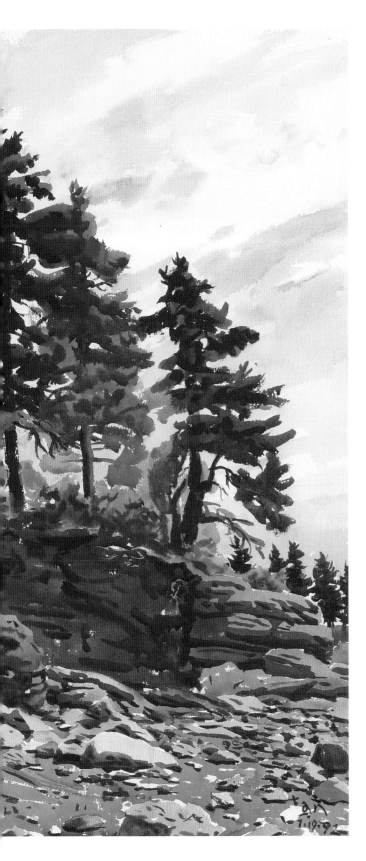

WATERCOLOR BASICS: SHAPE AND LIGHT VALUE

WITHDRAWN

CHINKOK TAN

NORTH LIGHT BOOKS
CINCINNATI, OHIO
www.nlbooks.com

Pottery Cove, St. Andrews
30" × 40" (76cm × 102cm)

ABOUT THE AUTHOR

Chinkok Tan has been a painter for over forty years. At a very young age he started painting in oil, and later adopted watercolor and acrylic. Early in life, his interest was interrupted by his schooling and later on in his adult life, by his teaching schedules—"all because we all have to make a living!" Tan eventually earned two teaching certificates, one as a teacher and the other as a certified art specialist from the prestigious Specialists Teachers Training Institute in Kuala Lumpur, Malaysia.

In 1967, Tan left his native Malaysia and migrated to Canada. He enrolled at the Ontario College of Art and Design and graduated with honors. Upon graduation, he became a full-time professional painter with his own studio, and he participated in open jury shows and won many awards for his watercolors. In 1973, he was hired by the Quebec Inuit Cooperatives—an organiza- tion wholly owned by the Quebec Inuit to repre- sent their artists—to introduce serigraph and batik painting workshops in Arctic Quebec for professional Inuit printmakers. In 1976, Eric Freidfeld, his former instructor and chairman of drawing and painting, offered him four perma- nent part-time courses to teach at his alma mater. He has been teaching there ever since, except in 1998 when he taught at the Corcoran School of Art in Washington, D.C. Tan also runs private summer workshops in Toronto and St. Andrews, New Brunswick.

Aside from painting, Tan also has illustrated and published one-of-a-kind books including *Wildflowers of North America*, a book of his poetry and personal writings, and a limited seri- graph book of Toronto. His works appear in many public, corporate and private collections in North America and Asia.

Watercolor Basics: Shape and Light Value. Copyright © 2001 by Chinkok Tan. Manufactured in China. All rights reserved. No part of this book may be reproduced in any form or by any electronic or mechanical means including information storage and retrieval systems without permission in writing from the publisher, except by a reviewer, who may quote brief passages in a review. Published by North Light Books, an imprint of F&W Publications, Inc., 1507 Dana Avenue, Cincinnati, Ohio 45207. (800) 289-0963. First edition.

Other fine North Light Books are available from your local bookstore, art supply store or direct from the publisher.

05 04 03 02 01 5 4 3 2 1

Library of Congress Cataloging-in-Publication Data
Tan, Chinkok.
 Watercolor basics: shape and light value / Chinkok Tan.—1st ed.
 p. cm.
 Includes index.
 ISBN 1-58180-043-6 (pbk. : alk. paper)
 1. Watercolor painting—Technique. I. Title.

ND2420 .T365 2001
751.42'2—dc21 00-051570
 CIP

Editor: Stefanie Laufersweiler
Interior production artist: Ben Rucker
Production coordinator: John Peavler

METRIC CONVERSION CHART		
to convert	to	multiply by
Inches	Centimeters	2.54
Centimeters	Inches	0.4
Feet	Centimeters	30.5
Centimeters	Feet	0.03
Yards	Meters	0.9
Meters	Yards	1.1
Sq. Inches	Sq. Centimeters	6.45
Sq. Centimeters	Sq. Inches	0.16
Sq. Feet	Sq. Meters	0.09
Sq. Meters	Sq. Feet	10.8
Sq. Yards	Sq. Meters	0.8
Sq. Meters	Sq. Yards	1.2
Pounds	Kilograms	0.45
Kilograms	Pounds	2.2
Ounces	Grams	28.4
Grams	Ounces	0.04

ACKNOWLEDGMENTS

I would like to thank a few wonderful people at North Light for their contribution in putting my book together.

Rachel Wolf, acquisitions editor, for accepting my book and helping me with the outline of the chapters. The changes improved the book enormously.

My editor, Stefanie Laufersweiler, for her outstanding editing and for being an absolutely delightful person to work with.

Greg Albert, editorial director, for his input. His suggestions were much appreciated.

The design and production staff, for putting my book together in the best light possible.

I also owe a lot to my son Jason, for teaching this old man how to use the computer to write, for his help in correcting my grammar and for printing out my final chapters for submission. I couldn't have done it without him.

I also want to thank my former wife, Dr. Mary Fanning, and Gary and Sandi Ralph for their editing of the original manuscript I submitted to North Light. And thank you to my many former students for encouraging me to write this book.

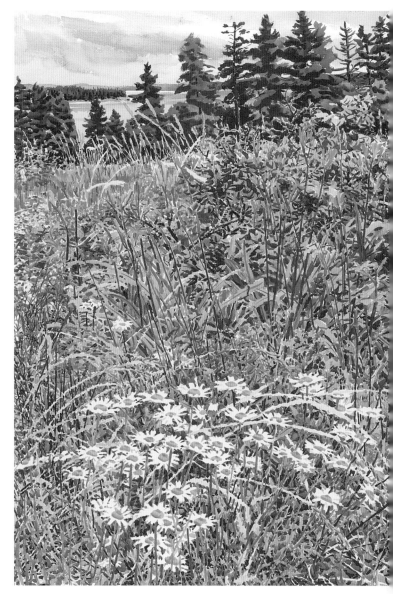

DEDICATION
To my dear son, Jason.

Field of Wildflowers
40" × 30" (102cm × 76cm)

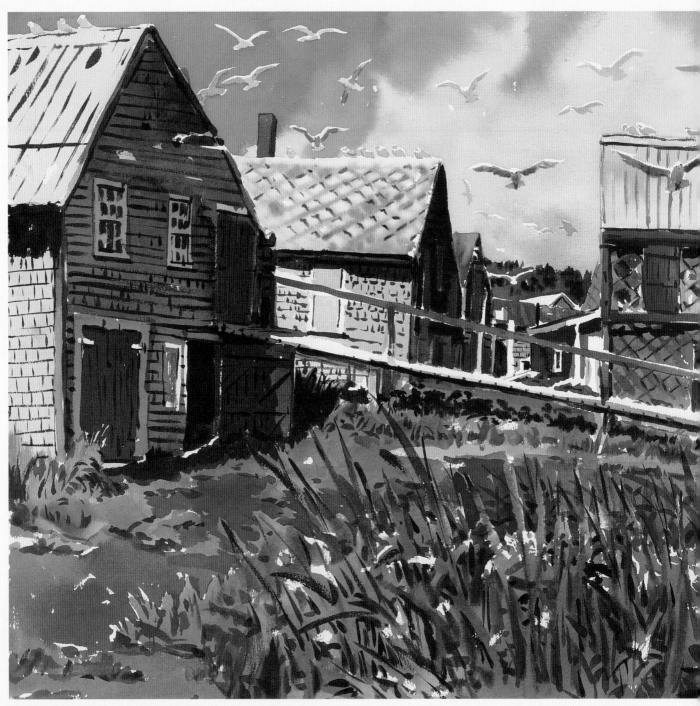

Herring Smokehouses
22" × 30" (56cm × 76cm)

CONTENTS

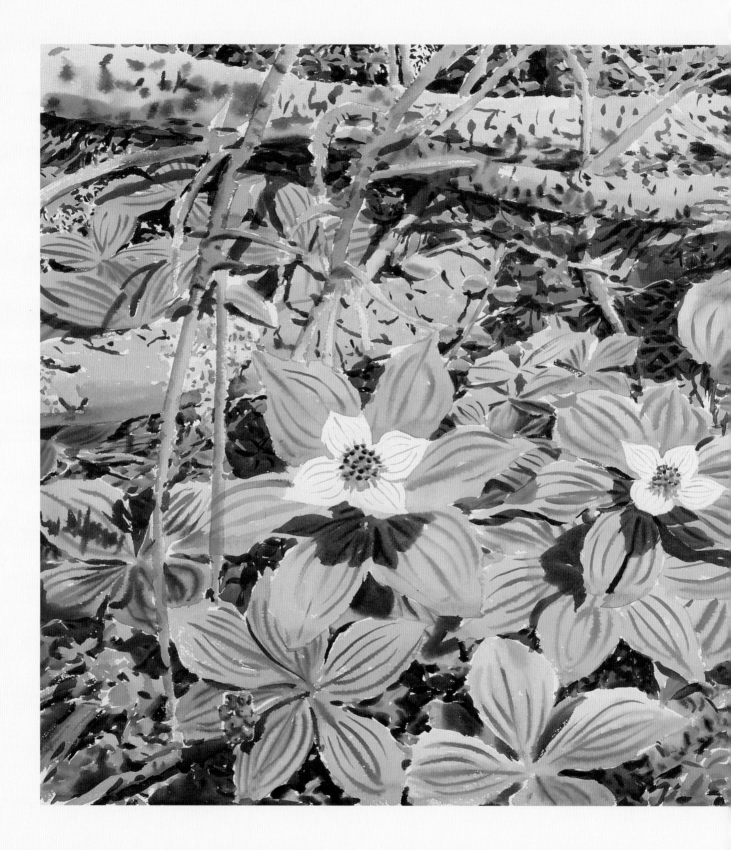

INTRODUCTION

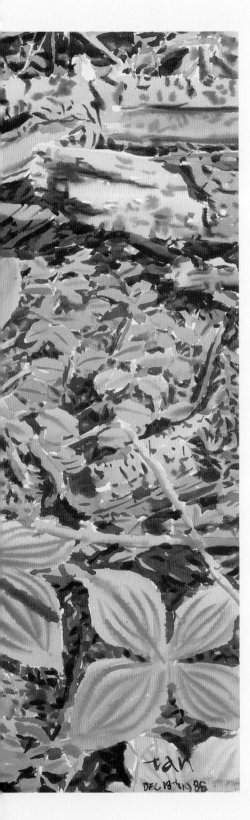

As far back as I can remember, I have never liked the idea of having to sketch my subjects before painting them. The experience of seeing other people doing it didn't influence me one bit! If there was a preparatory process that I felt had nothing to do with the process of painting, I just didn't do it. Call it stubbornness if you like, but I call it having the insight not to adopt crutches that would inhibit my growth and development later.

I was wise to follow my instincts and common sense. Because of them, I have developed a way of seeing that has helped me to render any conceivable subject, enabling me to paint directly on the paper with the right proportion and perspective on the very first try—each and every time!

This book teaches you how to see and simplify your subjects. In fact, it trains you to simplify the whole process of watercolor painting, without simplifying the result. You won't have to take anatomy courses or delve into the mysteries of perspective and color theory. My method suggests that every subject reveals itself in light values and shapes. When you finish this book, you should be able to paint anything without sketching.

Over two decades, I have taught students how to paint in watercolor. One of the most pleasurable parts of these experiences has been watching students learn how to paint within a few days. I have watched the timid, inhibited brushstrokes of these students evolve over very short periods of time into successful styles uniquely their own. It is all about painting with confidence. Using the lessons in this book, you too will be painting wonderful watercolors in no time.

Forest Floor
22" × 30" (56cm × 76cm)

9

Supplies

Supplies for my method of painting are few and cheap. You won't need more than eighty dollars to get started. Using inexpensive materials doesn't necessarily mean inferior quality just as expensive materials aren't necessarily good quality. What's important is that the pigments are permanent (lightfast) and the papers that you paint on are acid-free.

Paints

The three primary pigments I use, made by Da Vinci, are Hansa Yellow Light (#242), Red Rose Deep (#276) and Phthalo Blue (#267). I used these colors to create all of the art in this book. I have tested these pigments for their lightfastness. My accountant friend has a painting of mine on a wall that is in direct sunlight for part of the day. It has hung there for eight years, and the painting looks as vibrant today as if it were painted yesterday. Use your own judgment when choosing what brand of primary pigments to use; color and lightfastness can vary.

Brush

I use a bamboo Chinese brush, which has a point and the proper size to perform all functions. This brush has two kinds of hair: white goat hair on the outside and gray rabbit hair inside. This combination results in the brush maintaining its point even when it has worn down. However, this brush cannot be left sitting in water when not in use, as the natural hair will soak up the water and the expansion will crack the bamboo holder.

A new brush needs to be broken in before it is really good for painting. A new brush will also shed some loose hairs that are lodged among the bound hairs of the brush. Use whatever watercolor brushes you like, but if you want to use a Chinese brush and can't find it at a local store or in a catalog, you can order it directly from:

Leo Wong
227 Cosburn Ave., Suite 602
Toronto, Ontario
Canada M4J 2L6
(416) 466-4935

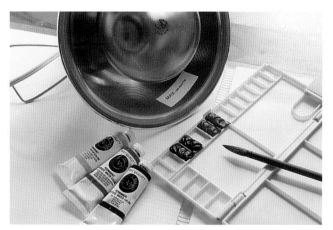

Some of the basics you'll need to get started are the three primary pigments, a bamboo Chinese brush (or round watercolor brushes of your choice), a palette and a reflector 'spot' light bulb and clamp-on lamp for lighting indoor subjects. I use the same palette and brush for everything from small watercolors to 40" x 60" (102cm x 152cm) paintings.

Paper

I prefer Winsor & Newton 140-lb. (300gsm) or 90-lb. (190gsm) cold-pressed watercolor paper. Other brands you can buy include Lana, Arches, Strathmore and Saunders. Watercolor papers that are not good for my method of direct painting are those heavily sized papers that resist water. Paper sold in blocks has more sizing than single-sheet paper. I recommend you buy a single sheet of paper, 22 by 30 inches (56cm × 76cm), and divide it into half or quarter sheets to suit your painting.

Miscellaneous

- White plastic palette with flat-bottomed compartments
- Resting board (I like to use plastic corrugated cardboard)
- Two clips and masking tape to secure paper to resting board
- Roll of toilet paper to remove excess water from your brush
- Sponge for wetting the back of a finished painting to flatten it between two flat surfaces (see next page)
- 150-watt reflector 'spot' light bulb with clamp-on lamp for indoor lighting of your subject (available at hardware stores)
- Portable stool or chair for outdoor painting

How to Flatten Your Paper

All watercolor paper shrinks, curls and buckles somewhat from the painting of one side. To flatten it or to remove the tension, follow the instructions below.

Wet the back of your watercolor paper with a medium-wet sponge, starting at the center and moving out toward the edges.

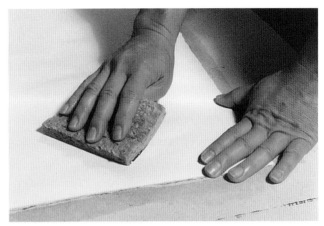

Be sure to wet the entire back of the paper and all the edges. Wetting the edges last prevents the water from running to the underside of the painting.

Once the entire paper has been moistened, place a piece of Plexiglas or plywood over it. If you use plywood, make sure it has been varnished or polyurethaned so the acid from the plywood won't transfer when it touches the wet paper.

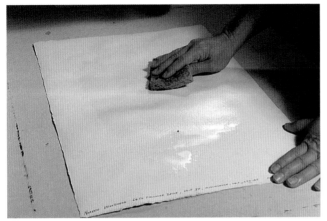

Finally, put a box of books on top of the Plexiglas or plywood to weigh it down. Leave it to dry completely before removing; it will take at least twenty-four hours. Now your painting is ready for framing.

Tip
If you want to speed up the drying time, put an acid-free mat board over the paper before placing a sheet of Plexiglas or plywood on top. The mat board will absorb excess water and help with the drying. This mat board can be used hundreds of times even if there are color stains. These stains won't transfer to the paper.

Techniques

There are three ways you can approach painting in watercolor—painting on a wet surface, a dry surface or a combination wet/dry surface. You can take any one of these approaches and combine it with your individual way of painting, the subject you paint, the colors you use and the way you see to create your own style or technique.

As you can see from the illustrations below, each surface gives a different look or mood to the painting. In some circumstances, the artist's choice of a dry, wet or combination wet/dry surface is an expression of that artist's own style or visual language. In other situations, the artist may choose a surface to create a certain effect in a painting because the effect is technically best.

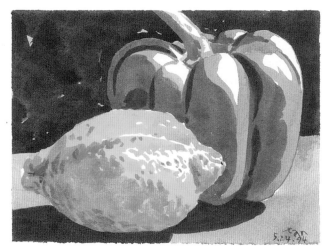

PAINTING ON A DRY SURFACE
This method is useful when you want shapes and details to be sharp and clear.

PAINTING ON A WET SURFACE
In this example, the results are almost surrealistic, capturing a mood rather than the reality of the subject.

PAINTING ON A
COMBINATION
WET/DRY
SURFACE
In this example, the two methods are combined, resulting in a softer look that still shows some detail.

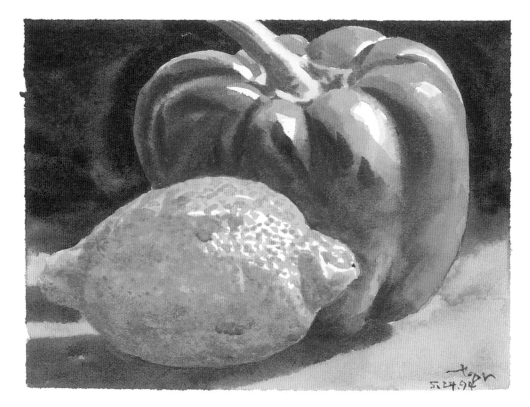

How to Lay a Flat Wash

To paint large areas of a painting, such as the background, you may want to lay a flat wash of watercolor. To do this, follow these instructions.

First, mix enough color to cover the entire area you want to paint (the ratio of water to pigment you use depends on the light value you want to use). Tilt your paper very slightly so water will accumulate along the edge of your stroke. With a fully loaded brush, paint from the top and across. Don't let the brush get less than half dry before reloading. Too much difference in the degree of wetness will create uneven washes.

When you have a small enclosed shape, you can leave it to paint later with a drier brush; otherwise the puddle of water may drip on the rest of your painting.

After reloading, continue to paint across from where you left off by just coming in contact with the wet edge, letting the water do the blending for you. Never go over what you have already painted; this will result in uneven washes.

Tip

To remove an accidental drip, first wash the color off your brush immediately and load it with clean water. Then brush over the wet drip to dilute it as much as possible. Add more clean water if necessary. Do this before the wet paint has a chance to stain the paper fiber. Never use a tissue to blot the drip; it will leave a dry stain that will be hard to remove later.

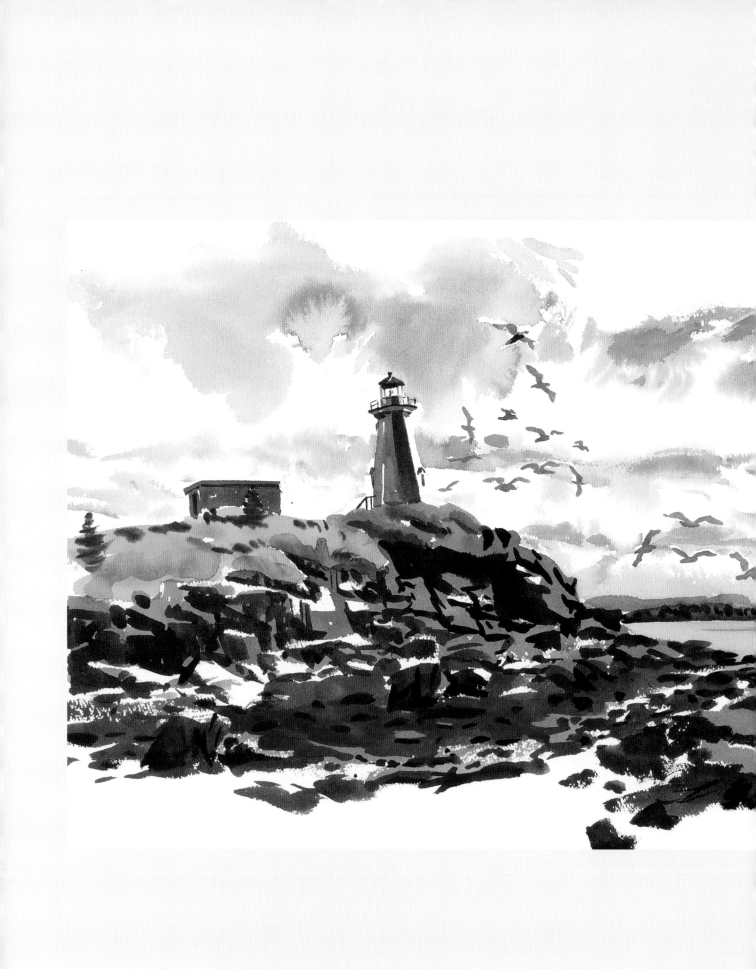

WHAT IS LIGHT VALUE?

Have you noticed how much light affects the appearance of color? Light is the master of color, controlling its appearance like a puppeteer controls the puppet. How a colored surface looks depends entirely on the value or degree of the light that falls on it. If the value of light falling on a color increases—getting brighter—the hue will appear lighter. If the light becomes very bright, the hue will turn entirely to reflected light and look white. If the value of light decreases—getting dimmer—the hue will appear darker, eventually disappearing into black. Between the two extremes of black and white, you'll see a range of colors related to the natural hue of your subject. These are called light values.

Lighthouse at Letete
15" × 22" (38cm × 56cm)

Seeing Light Values

All subjects have light values. This is because subjects are not flat. Their surfaces have differing amounts of light falling on them depending on whether the surface is facing the light source, at an angle from it or facing away from it. Seeing light values on a subject will help you paint its elements.

The illustration to the right shows a fully graduated light-value range for three different colors: green, yellow and orange. Notice how the increase and decrease of light on the natural hues creates changes in the colors. As the amount of light that falls on the natural hue increases, the hue appears lighter, eventually becoming white—a reflection of the light. As the amount of light decreases, the hue gets darker, gradually fading to black.

Using the range of light values for each of these colors, you can paint all the elements of objects that are of these same colors—a green pepper, a lemon and a pumpkin, for instance. The different light values represent highlights, shadows and other elements of a subject, and combining a number of values will make a painting complete.

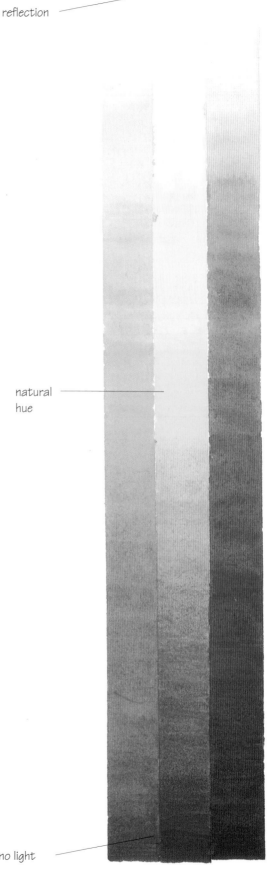

reflection

natural hue

no light

Look at this picture of a banana. Colors on different parts of the banana match specific areas on the yellow-hue color bar. See how the light values of the yellow hue create the banana's space, form, light, shade, plane, structure, perspective, proportion and texture. These are called the subject's secondary elements because they are all created by the two basic primary elements: shapes and light values (we won't worry about the shapes just yet).

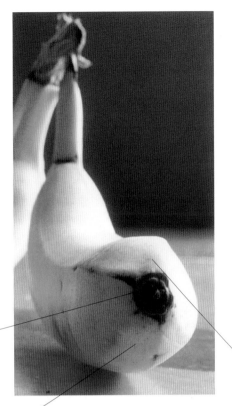

With only one light value present, the objects around us would appear as I have illustrated here—flat!

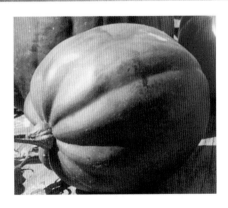
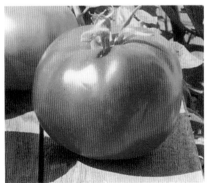

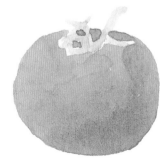

Scaling Light Values

Light values are the first thing you need to learn in order to mix the proper colors. But before you can do that, the light values must be scaled. We scale light values for the same reason we scale musical notes. The scale helps us to be more objective and precise, so we can paint while minimizing the amount of trial and error. Completing a painting involves many shapes, hues and light values, and all of these elements have to be balanced correctly to achieve color harmony for a unified composition. To simply look at the many subtle high and low light values without a scale for a guide is not giving your eye the help it needs.

Another reason why the light values should be scaled is that we do not necessarily have to use all the light values we see. We don't even need to use all the light values in the scale, for that matter—just as a composer need not use every note in a scale to create a melody.

In fact, you really need only two light values to transform a flat shape into a three-dimensional representation of your subject—that's right, only two! The number of light values you use will depend entirely on the visual vocabulary that you choose to paint with. For example, a more photo-realistic painting uses four to seven light values, but an impressionistic painting may use only two to four light values.

Creative painting is all about editing. It is not simply imitating everything you see. You simplify when you scale the light values, and you further simplify by using only part of the light value scale. As you progress through this book, you'll begin to see that my painting process is largely about simplification.

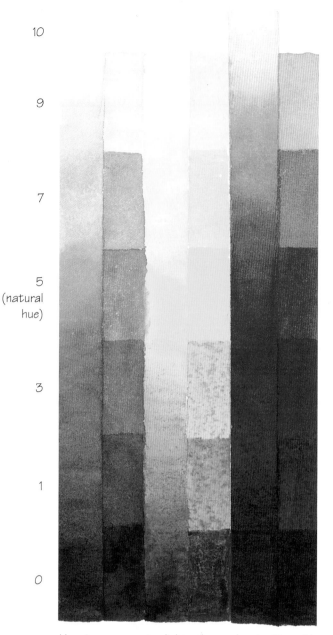

Here is a seven-step light value scale, starting with the natural hue of three primary colors (value 5). The scale ranges from value 0 (absence of light) to value 10 (full light), with values in between representing different levels of light affecting the natural hue. Values 2, 4, 6 and 8 are merely transitions that our eyes can't readily distinguish. Therefore, they need not be painted unless we want to be extraordinarily exact.

Identifying Light Values on a Subject

In this method of watercolor painting, we assume that each hue has a scale that runs from 0 to 10, with black given a value of 0 and white a value of 10. (Think of black as the absence of light, or zero light, and you will have no trouble with this concept.) The scale includes all light values between black and white, but the naked eye can't really recognize very subtle changes in light values. For our purposes, it's good enough to identify seven light values on our scale. So, the seven critical values are represented by the numbers 0 (black), 1, 3, 5, 7, 9 and 10 (white), with value 5 representing the natural hue of the object.

If value 0 gives us black, then value 1 gives us a little light reflected from an object. Value 3 allows us to see the object fairly clearly but still in a way we might call "shaded." When we get to value 5, we are seeing the actual or true hue of the object—this is as close as we will get to the real color of the subject we are painting. Value 7 moves us toward the bright side of the hue, and when we get to value 9, the object is almost white because of the high intensity of the light reflected from it. Value 10—a total reflection of light—is simply the white of the paper.

It is vital to identify these seven light values in the subjects you want to paint. We must begin painting each object with the highest light value—representing the brightest light reflected from the object. We move to darker or lower light values by painting over the first and brightest color, or highest light value. Because watercolor is a transparent medium, we cannot paint a light color over a darker color without the dark one showing through. In other words, we have to apply our light values in a descending order.

You have to see light value scales at work before you see the true value of working with them. Once you see a scale in action, you'll see how effective it is at producing a painting with drama that can be created only by contrast, as well as the accuracy that can result only from capturing true light values in your work.

See how the numeric light values are assigned to the tomato and squash in this picture. Shiny surfaces reflect more light than non-shiny ones. For instance, you see a value of 10 on the tomato, but hardly on the squash (so we give it a 9). Notice that the shaded area of the tomato is given a value of 3, while the most shaded part of the squash is a value 1. That's because of the darker coloring of the squash. In painting, we often have to do some editing to effectively portray our subject, and this includes seeing colors in your own way to create light value scales.

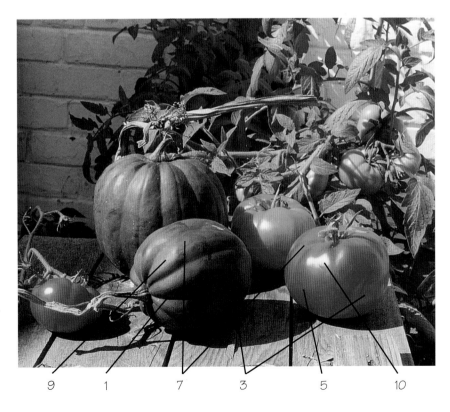

9 1 7 3 5 10

Applying Light Values in a Painting

You really need to use only three light values to accurately paint your subject: value 7 or 5 to create shape and highlights, value 3 for the shadows, and value 1 for details. The example below demonstrates how three light values are used to create a flower.

Reference photo

VALUE 10 – REFLECTION
In transparent watercolor, you leave the white of the paper.

VALUE 9 – STRONG HIGHLIGHT
I seldom use this number, except to paint the sky or when I want a very subtle effect.

VALUE 7 – SHAPE AND HIGHLIGHT
Usually, you paint this value first to create the shape of your subject. It also creates the light that exists on a subject on a sunny day.

VALUE 5 – NATURAL HUE
This value has the same purposes as value 7, only it is more intense. I seldom use this value along with value 7.

VALUE 3 – SHADOW
This value is used to begin modeling your subject after the shape has been painted.

VALUE 1 – DETAIL
Value 1 is used for details, like the veins of a flower.

VALUE 0 – ABSENCE OF LIGHT
This value is used for areas of no light, like a hole or crack on a rock.

Exercise: Light Values on a Green Pepper

Generally, it is not necessary to use all the light values on a scale, even for a very realistic painting. But for the purpose of identifying the light values on a subject, I will use all of them in this example. Note: Since value 10 is represented by the white of the paper, it is not shown on any of the value scales in this book.

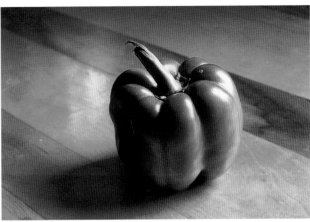

Reference photo

Step 1

I started with value 9 to establish the shape of the stem first, then the pepper. The areas of reflected light on the pepper, value 10, are left unpainted. Normally I would work on the pepper shape only from this point on so I wouldn't have to wash my brush to change color for the stem. In this example, however, you'll see the stem and pepper as though they were painted at the same time.

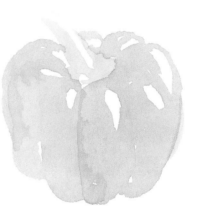

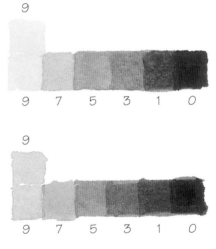

Step 2

After mixing value 7, I look closely at the reference photo to locate the value 9, and paint the rest of the pepper in value 7. I don't wash my brush after painting each value; I just keep mixing lower light values as I go along.

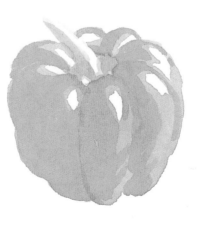

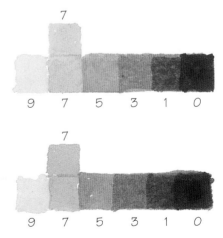

Step 3

With value 7 in my brush, I mix value 5. Now I look for value 7 on the pepper and paint the rest in value 5. Notice how the pepper is starting to look three-dimensional as I add light values.

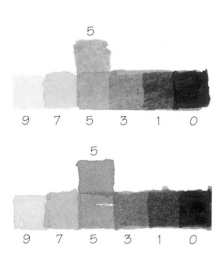

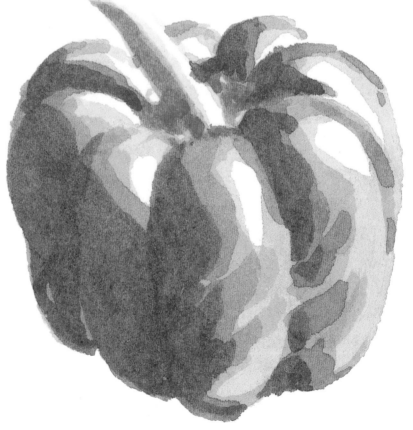

Step 4

With value 5 still in my brush, I mix value 3. Now I look for the shadow shapes to paint.

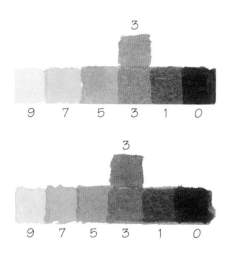

Step 5

After mixing value 1, I look closely at the shadow shapes to locate value 1 areas to paint the details. (It is hard to see this on a photo.)

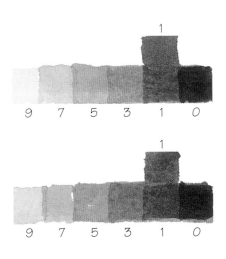

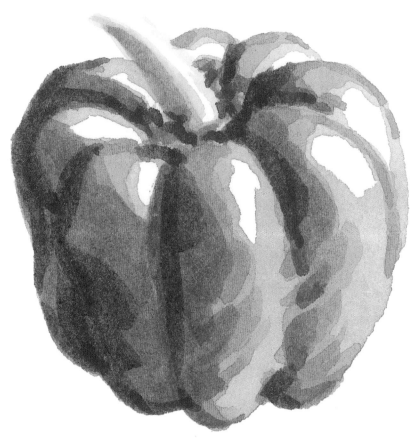

Step 6

I finish by mixing my value 0, black, and painting it where no light exists on the pepper. This is always the last value to be painted, and it usually occupies only very small areas.

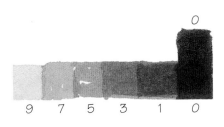

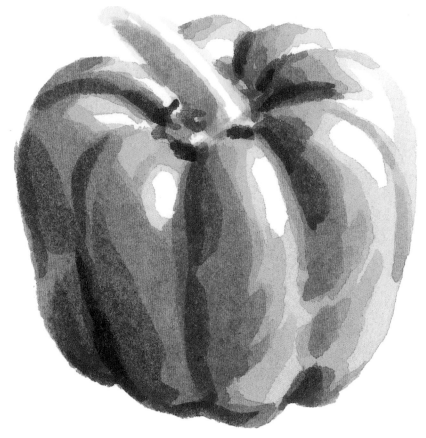

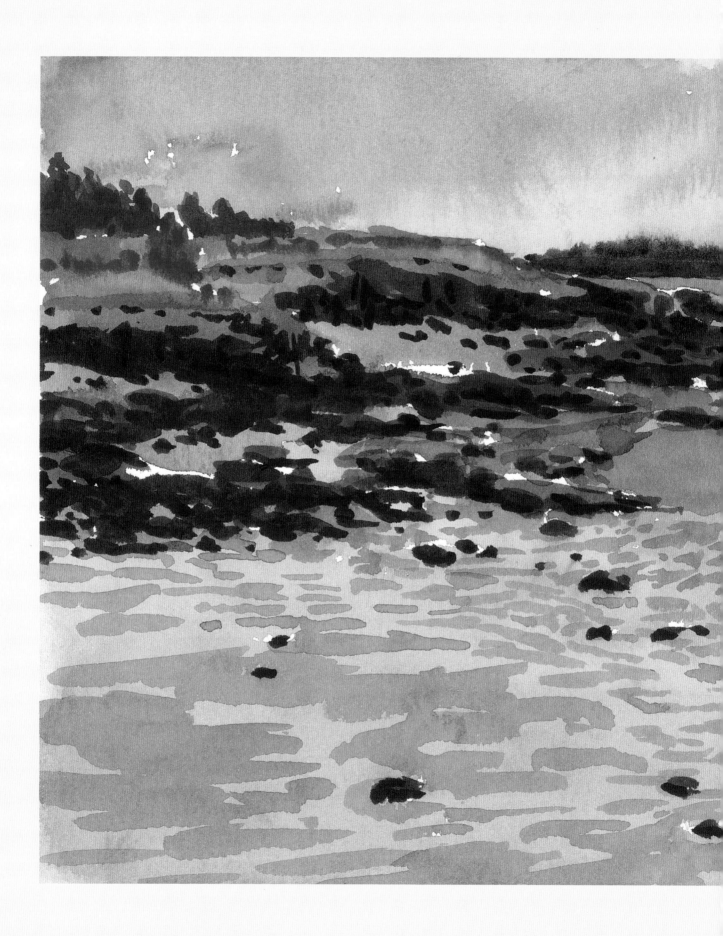

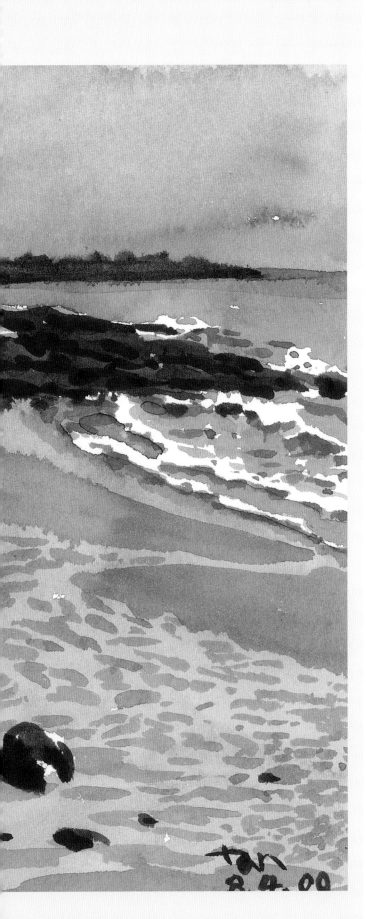

2

HOW TO MIX LIGHT VALUES

At its root, the process of painting involves mixing colors. It is a skill you must develop in order to be able to mix the colors and light values you want. Mixing paint to create light values is necessary. You can't avoid it even if you were to buy all the available colors in the store! In this chapter, you will learn about primary, secondary and tertiary colors, and you will learn how to mix and paint your own light value scales. At the end are charts that will help guide you in mixing many different hues and light values.

Rocky Beach
7" × 10" (18cm × 25cm)

Three Types of Colors

All of the art in this book was created using the three primary pigments: yellow, blue and red. Primary colors are primary because they are not created by mixing other colors. Primary pigment is what you will use to mix all your other hues and their light values, including black.

A secondary hue is created by mixing two primary pigments. For example, yellow and red make orange; red and blue make purple. A ter-tiary hue is made by combining all three primaries. Of course, you can mix an infinite number of tertiary hues from the three primary pigments. Tertiary hues will vary depending on the amount of yellow, red and blue in your mix. After you develop a basic understanding of mixing secondary and tertiary colors, you will be ready to create a light value scale.

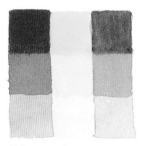

Primary colors

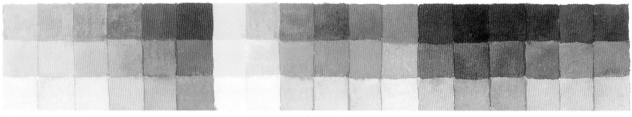

Secondary colors

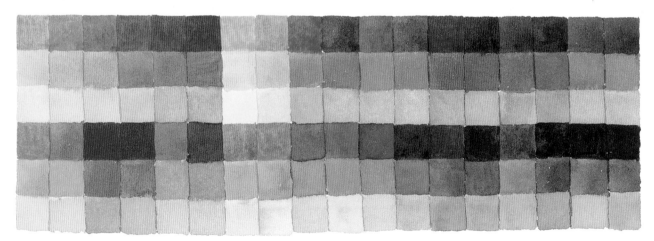

Tertiary colors

Exercise: Make a Light Value Scale

In order to paint, you must learn to mix light values. It is easier to mix all hues and their light values if you use only the three primaries. As you go through this process of mixing hues and their light values, you will find your perception sharpening. Soon, you will be able to identify values on your subjects and match these in your mixing of paints. Try this exercise to make a light value scale.

Tip
To have better control of your paints, use them hardened instead of soft. Fill two small compartments on your palette with primary red and primary blue, level the paint and let it dry. To lift paint for mixing, run the wet tip of your brush over the hardened paint. Use primary yellow soft because you'll need more of it to mix with the other two primaries for most hues.

Step 1
Wet your brush, then scrape it on the side of your water container twice to remove some water. Lift red paint with the tip of your brush. Then mix paint and water on the mixing tray. Matching the illustration as closely as you can—without using a ruler or pencil—paint a bar long enough to be divided into four squares. This bar has a value of 5 (the natural hue). Do not wash your brush, and save the remains of your red pigment for later use in step 5.

Step 2
Dip your brush about a quarter-inch (0.6cm) into the water. (The further down you dip the brush the more water you will fetch, so be aware of how far to dip to fetch the right amount of water the next time.) On a clean mixing tray, mix the pigment with the water that is on the brush until it has a value of 7, like the 7 in the illustration. Paint a square at the top of your light value bar. If the value 5 bar is still wet, follow the tip below. Do not wash your brush.

Tip
You may have trouble painting individual squares of a scale without the paint spreading out of control. Bleeding occurs when you touch a wet edge with a brush that is too wet. To prevent this, paint your new square from the top down, but don't touch the bottom wet edge until you remove some water from the brush. (A roll of toilet paper works well for this.) Then paint to touch the wet edge and complete the square.

To prevent this: Do this:

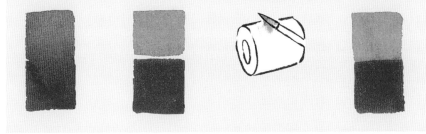

Step 3

Dip your brush containing the value 7 about a quarter-inch (0.6cm) into the water. Mix it on the spot where you previously mixed value 7. You should have a mixture that is more diluted than before. Paint a new square above value 7 on your scale; this is value 9. You now have four "squares" of value 5, and one each of values 7 and 9. Value 10 is the white of your paper. Do not wash your brush.

Step 4

Pick up the value 5 you saved in step 1 and add a little more red pigment to make it thicker and more intense. (You may need to add water if the brush is too dry.) Then add blue and yellow to the red in gradual increments. Be gentle with the blue, as it is a very concentrated pigment. Apply this value 3 to the bottom three squares, leaving value 5 untouched. Again, don't wash your brush.

Step 5

Mix value 1 by adding more blue and red to the value 3 mixture on your brush. Keep in mind that the lower the light value number, the thicker the solution should be. Use your eye as your guide and refer to the illustration. Paint value 1 on the bottom two squares. If value 3 is wet, you can still paint on it because the thickness of the value 1 mixture will prevent the paint from spreading. Leave the paint on your brush.

Step 6

Add more red and blue to what is on your brush and stir for a deep indigo. Then stir in some yellow. At first the color will turn greenish, then black when the right amount of yellow is used. Paint value 0, a black square, on the bottom of your scale. You now have a scale that begins with a black square, value 0, and ascends value by value to 10 (white). Value 5 in the middle represents the actual hue of the red pigment.

Tip

All light values 3, 1 and 0 must be a tertiary color mixture. At first it may be hard for you to determine how much of each color to use, but it does get easier with each scale you paint. In this example, the color bars on the left indicate how much of each pigment was used for the different values.

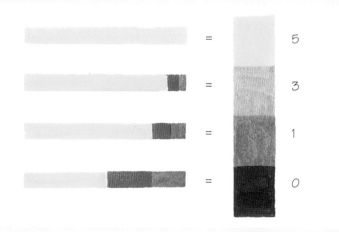

Exercise: More Light Value Scales

Now that you've completed one light value scale, try painting scales for the rest of the color spectrum, including white and black, following the illustration below. When you finish mixing these nine hues, you should be ready to apply light values to paint a subject.

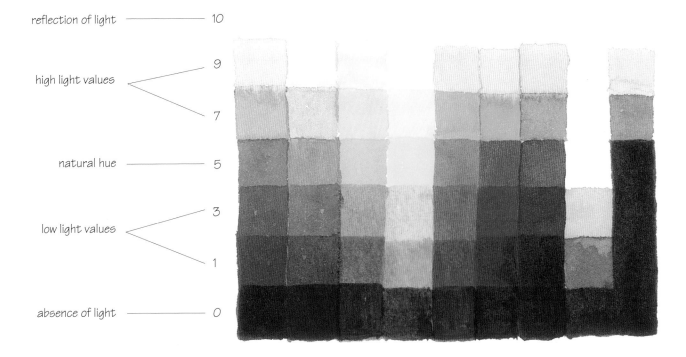

reflection of light —————— 10

high light values —— 9
 —— 7

natural hue —————— 5

low light values —— 3
 —— 1

absence of light —————— 0

Tip
To control spreading when painting lower values (3, 1 and 0) on a wet surface, use yellow as a thickener before adding red and blue to your mixture. Don't worry about using too much yellow; the inherent brightness of the hue will not darken the mixture.

Light Value Reference Charts

On the following pages are charts that will help you mix many hues and light values. As I mentioned earlier in this chapter, you need only the three primary colors to mix all the colors and light values you need to paint. Keep in mind, however, that primary colors can vary from brand to brand. There is no standard in naming or in the composition of pigments among the many brands available.

These charts are broken down roughly into purples, blues, greens, yellows, reds and browns. Other warm hues are added to the brown family, for example, because I felt a need for creativity—to arrange color harmony by unity of colors. Harmony by unity of colors means using only warm colors together, or only cool colors. Most of these are tertiary hues, as the world is mostly made up of these colors.

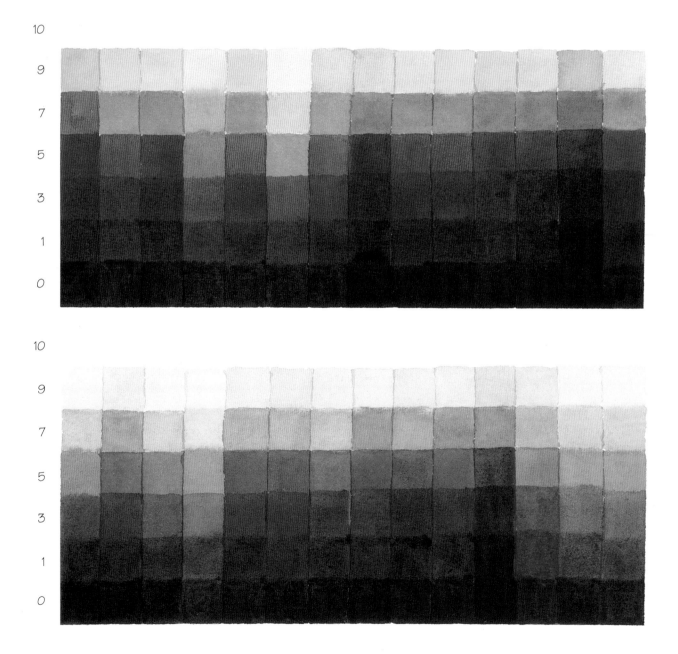

10

9

7

5

3

1

0

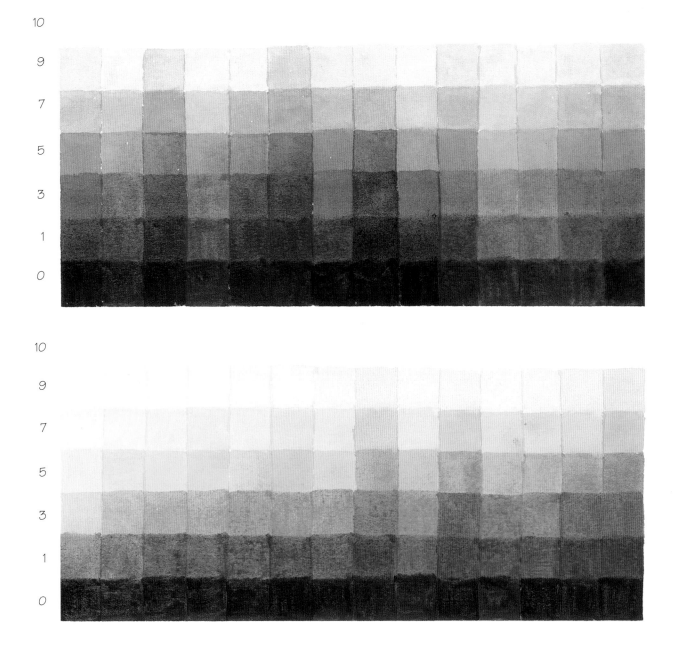

10

9

7

5

3

1

0

10

9

7

5

3

1

0

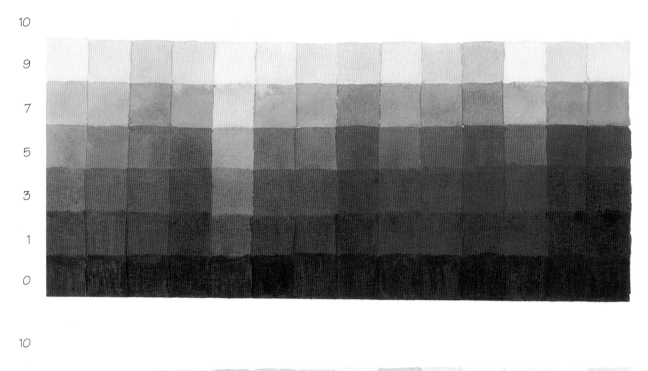

10

9

7

5

3

1

0

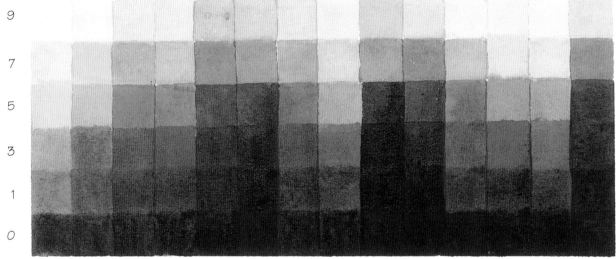

Using Light Values Correctly

On this page and the following two pages, we have three paintings of the same subject: baskets of vegetables and fruit. In the painting below, scales of light values were not used, and it shows in the results. The next two examples show how using light value scales improves the painting.

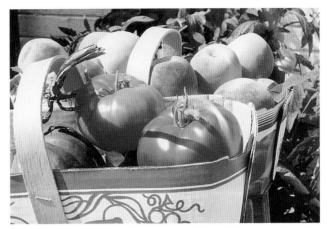

Reference photo

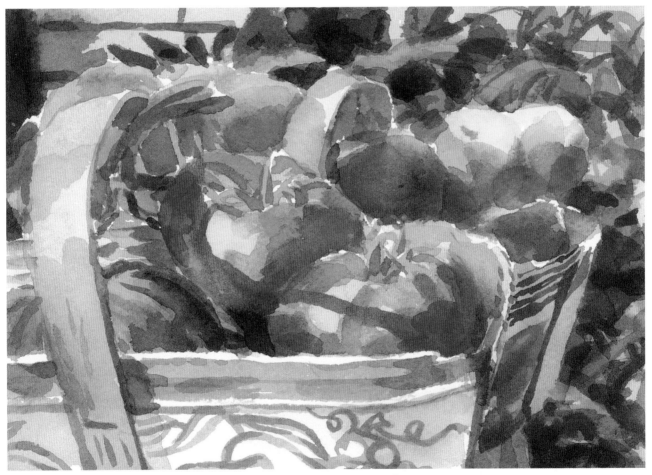

In this painting, we find an imbalance in the use of lights and darks. Instead of using light values, the artist has used dark colors. Dark colors are not the same thing as low light values because the colors are not related to the hue under a particular light value. There is also no consistent use of light values to create balance and harmony among all the colors.

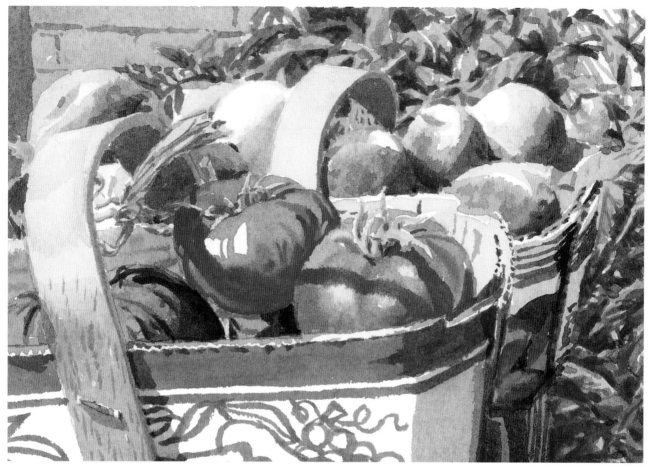

For this painting, I have used a number of light values for each subject. Below are the light value scales used for some of the different items and the values that were painted. Value 10, the total reflection of light, is indicated by the white of the paper for the tomatoes and peaches.

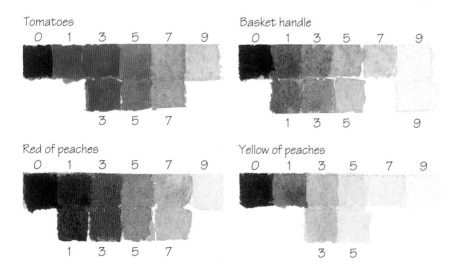

Tomatoes

0	1	3	5	7	9

Basket handle

0	1	3	5	7	9

Red of peaches

0	1	3	5	7	9

Yellow of peaches

0	1	3	5	7	9

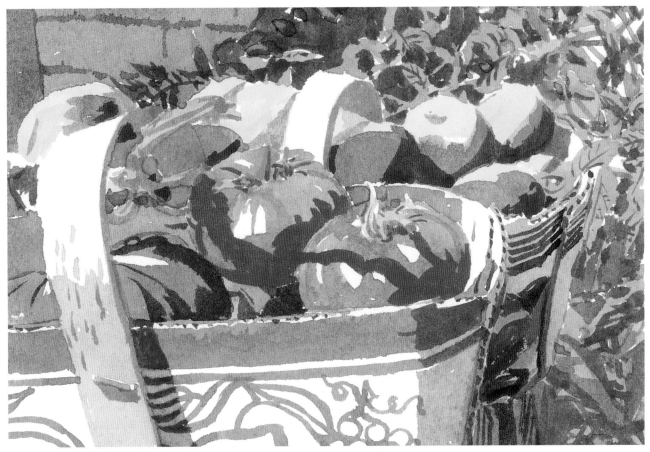

This painting was created with surprisingly few light values. Compare it with the one on the previous page and you will see very little difference in the final result. Both paintings are far better than the first one in which light values were ignored. These works show that it is essential to see light values to paint, but it isn't necessary to use many light values. Value 10 (white) is used for the basket handle and tomatoes.

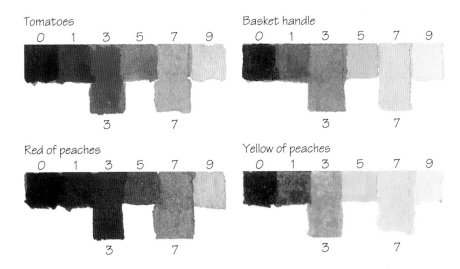

Tomatoes

0	1	3	5	7	9

3 7

Basket handle

0	1	3	5	7	9

3 7

Red of peaches

0	1	3	5	7	9

3 7

Yellow of peaches

0	1	3	5	7	9

3 7

Exercise: Paint a Wild Rose

Practice making light value scales to paint the flower in this reference photo. In this exercise, you will simplify what you paint and use only the following values:

1. 7 or 5 to create shapes and highlights;
2. 3 to create shade (shadow); and
3. 1 for details.

Use the illustrations and scales to help you. Remember, your colors don't have to perfectly match what you see on these pages. The important thing is to practice mixing colors and light values and applying them to your subject.

Reference photo

Step 1

Crop your composition to focus on the pink rose. (I moved the stem with sepals only from behind the rose to the right of it for a better composition.) Make your light value scales for the different elements of the flowers, using the scales below as a guide. Paint value 7 of the flower centers, stamens, rose petals and leaves, and value 5 of the stems and sepals.

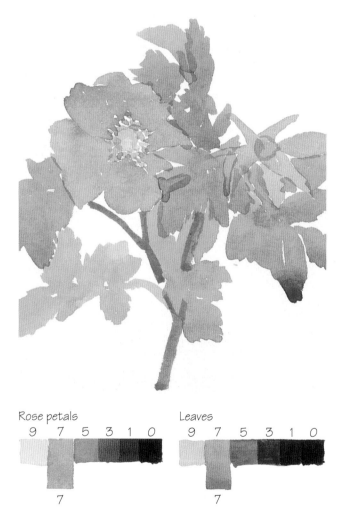

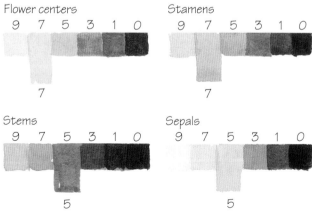

Flower centers
9 7 5 3 1 0
7

Stamens
9 7 5 3 1 0
7

Rose petals
9 7 5 3 1 0
7

Leaves
9 7 5 3 1 0
7

Stems
9 7 5 3 1 0
5

Sepals
9 7 5 3 1 0
5

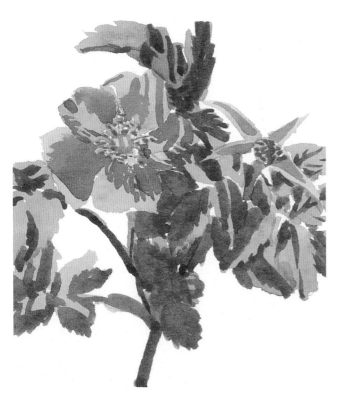

Step 2

Paint value 3 of all parts of the flower, creating the form of its petals, leaves and other elements.

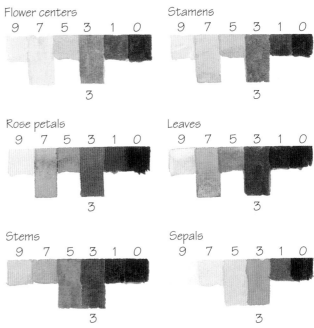

Flower centers

9 7 5 3 1 0

3

Stamens

9 7 5 3 1 0

3

Rose petals

9 7 5 3 1 0

3

Leaves

9 7 5 3 1 0

3

Stems

9 7 5 3 1 0

3

Sepals

9 7 5 3 1 0

3

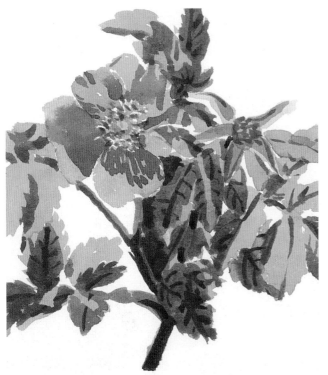

Step 3

Add details with value 1 as desired. I added value 1 of the stamens, leaves, stems and sepals, but left the rose petals and flower centers alone. It all depends on how you see your subject.

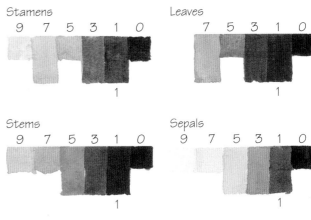

Stamens

9 7 5 3 1 0

1

Leaves

7 5 3 1 0

1

Stems

9 7 5 3 1 0

1

Sepals

9 7 5 3 1 0

1

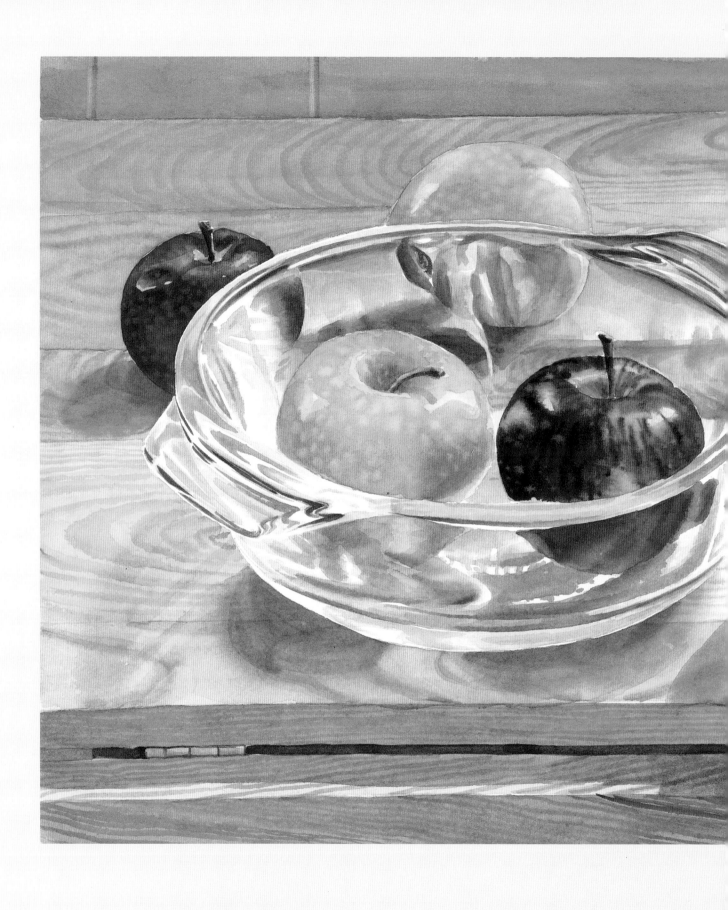

SEEING AND PAINTING CORRECT SHAPES

If you can see the shape of a subject, you can capture that shape in paint. There are no tricks to seeing a scene so that you can paint it. Avoid "manipulating" a painting subject— measuring it, dissecting it with drafting tools, finding an elusive "vanishing point" or, in other ways, using your mind to define what your eye sees. When you begin defining a subject with your brain, you risk altering that subject to fit your preconceived notion of it. When you trust your eye, you see the subject the way it is and in the way it should look in your finished work.

Apples and Glass Bowl
11" × 16" (28cm × 41cm)

Seeing Shapes as Silhouettes

Seeing shapes is a basic skill required to paint your subject in proportion and perspective. What is a shape? Well, if you strip an object of most of its light values, you are left with a silhouette or, in other words, its two-dimensional, featureless shape. A shape has only one light value, and therefore does not show the subject's elements—space, form, plane, structure, light, shade and texture.

You may have difficulty seeing an object's basic shape at first for two reasons: 1) the light values on the shape can distract you from seeing it, and 2) the foreshortening—defined as the change in perspective and proportion of a subject caused by distance—can get you thinking about how the shape is supposed to appear instead of seeing how it really looks.

When you are trying to 'see' a shape, you are trying to eliminate the elements that give a shape three dimensions and reduce the shape to a flat, featureless silhouette. Once you can do this, you can capture an essential shape directly on your paper without measurements, drafting or sketching an outline.

FLOWER FACE-ON
In this illustration, a flower is viewed from an angle in which all the petals are flat. Even without all its elements, this object's shape is easily recognizable. You can work out in your mind how to paint this shape without necessarily seeing it.

FLOWER FORESHORTENED
This illustration shows the flower foreshortened. Its petals are difficult, if not impossible, to imagine. They must now be seen by the eye to be painted properly. When painting these foreshortened petals, we simply see each petal as a shape without questioning the way it recedes or approaches us. This seeing of shapes allows us to paint anything—foreshortened or not.

SEE SUBJECTS AS SHAPES FIRST

You begin to paint the subjects in these reference photos, a flower and a banana, by painting their silhouettes, or shapes, rather than drawing their outlines. If you can see subjects as shapes, you won't feel the need to sketch edges and you will find it much easier to paint foreshortened subjects.

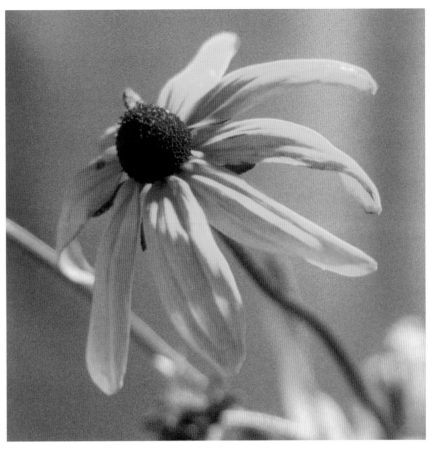

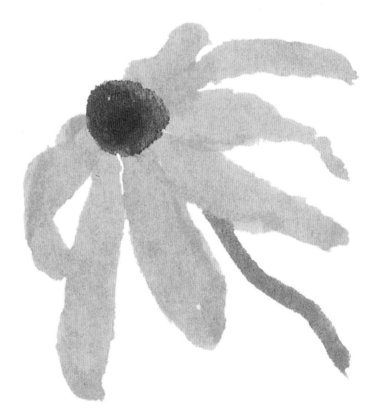

Paint Shapes—Don't Outline

Never focus on edges or outlines to try to draw a subject before painting it. Seeing the edge of a subject is seeing only part of the subject. It is incomplete seeing. When you see only an edge or curve, your seeing brain doesn't recognize the shape that guides your edge. The edge or curve may seem right to your brain at the time, but it will look wrong when the painting is finished since it doesn't match the shape you see.

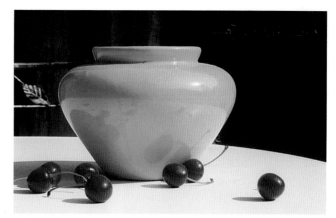

Reference photo

It is harder to see an outlined shape in development. This is because the white inside the line is the same as the white outside the line. When you sketch you tend to look at one edge independent of the others, often resulting in an inaccurate shape.

It is easier to see a painted shape in development because the painted area creates a contrast to the white background.

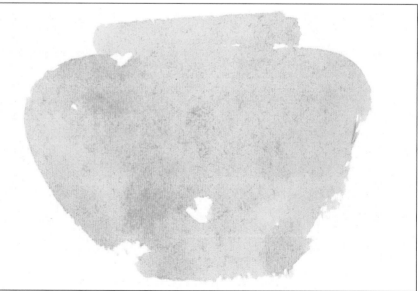

Exercise: Seeing a Complex Shape

Objects come in all shapes and sizes. Some are simple—like a single leaf—while others are complex or busy, such as this flower. To paint this flower, break up its overall shape into individual shapes. For this exercise, since you are painting only the flower's shape, one color is all that is needed.

Begin with the cone shape; it will be easier to relate your other shapes to this center. Then add the petal shapes one at a time, relating them to one another and retaining scale.

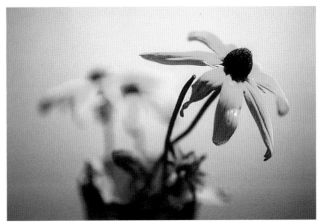

Reference photo

Step 1

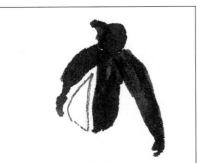

Step 2

Step 3

Step 4

Step 5

Step 6

Step 7

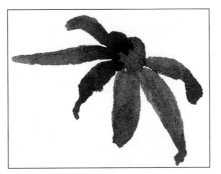

Step 8

Step 9

Seeing Peripherally

Peripheral viewing or seeing means looking at the whole picture as it builds and at relationships between shapes. When you're painting more than one shape, it is essential for you to shift your eyes back and forth from the shape that you are painting to the shapes you have already painted. This overall peripheral view, or seeing things adjacent to your main subject, helps you paint every shape to the same scale. Seeing shape and viewing peripherally is how you paint to achieve proportion and perspective.

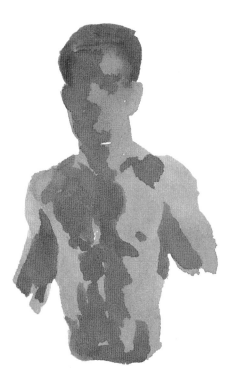

This sketch shows a figure painted out of proportion. The shoulders are too narrow in relation to the head, and as a result, the torso is too small, or out of proportion. When one edge is wrong, it affects the whole shape—this is why you shouldn't look at edges only when painting a subject.

In this sketch, the figure is painted in proportion. The shoulders are of the right width in relation to the head, and the torso is in proportion to the head. Seeing peripherally will help you paint in proportion.

Shapes Don't Have to Be Perfect

It is not important to paint a shape perfectly. A creative painter applies artistic license. Shapes are often changed, dropped or moved for a better composition. I encourage you to read shapes and try to get them right, but only so that you develop artistic confidence.

Reference photo

Painting directly to match shapes accurately is important only to build your perception and to give you confidence to change shapes according to your own wishes and whims. In this painting, shapes were changed from those in the photo to create a better composition. Light values also were changed to provide better space, form, light, shape, plane, structure and texture.

Exercise: Seeing a Complex Still Life

For this exercise, look at the many objects in the reference photo as a collection of shapes. Use your three primary pigments to mix the black to do this exercise. Start with a foreground shape and paint from the center out to the edges. Leave spaces to separate the shapes, and then paint the next shape starting at the shared boundary. Complete the shapes of one subject before moving on to the next. You can follow my example, but you don't have to follow it exactly—paint the shape that you think is easy to see first.

Reference photo

Step 1
Rough in the vase shape, painting from the inside and moving out toward the edges.

Step 2
Paint the edges for the correct shapes. Leave spaces at the rim to indicate flower stems and the inside of the vase.

Step 3

Take advantage of the shared boundary and start there to paint the first foreshortened banana shape. Leave a space to separate the two shapes.

Step 4

Start the next shape at the shared boundary to paint the next foreshortened banana. Complete all the banana shapes before moving on.

Step 5

See the negative space as a shape to paint the edge of the teapot. Now see the teapot shape to paint it. Leave uneven spaces between shapes to make for a more interesting painting.

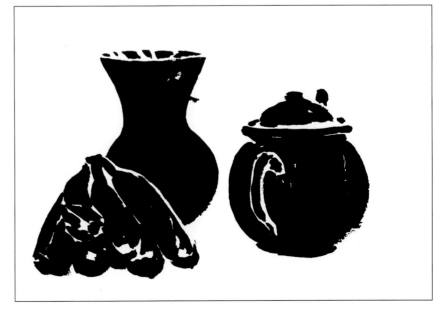

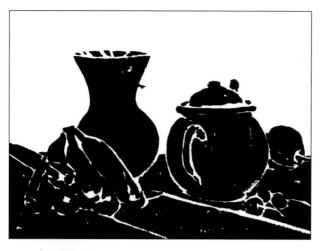

Step 6
Paint the pear and cherries next. Then add the table and cloth shapes to pull it all together.

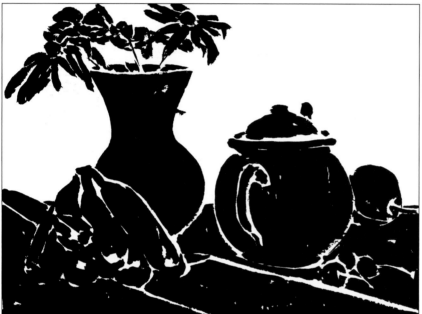

Step 7
Paint the flowers in the vase. Now the entire foreground is complete.

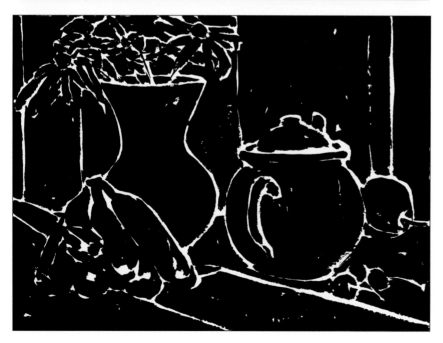

Step 8
Complete the background shapes to finish the painting.

Shapes First, Then Light Values

Once you learn how to paint shapes to create a subject's perspective and proportion, you can then use light values to reveal a subject's other elements—space, form, light, shade, plane, structure and texture. No matter what subject you are painting, if a shape seems too busy or complex, break it up into simpler shapes to make it easy for your eye to see. After you paint an object's shape, you can add its elements by painting other light value shapes over it or next to it.

Once you've learned how to see and paint shapes . . .

. . . you can use light values to create all the other features of your subject.

APPLYING THE THREE-STEP PROCESS

Now that you have seen the theory behind this method of seeing and painting, the examples in this chapter show you how to apply the three-step process of painting shape, shade and detail to complete a subject with all its secondary elements. You'll also see some subjects where the use of two steps is enough, and when the use of four steps is appropriate. Some of the paintings have accompanying reference photos so you can see where the light values and shapes originated. All paintings have light value scales showing the colors used.

Bright Light
5½" × 8½" (14cm × 22cm)

Tree

For this tree, paint the trunk first, since it is easier to see and relate the complex shapes of the leaves to the trunk than the other way around. When you are painting the shapes of the leaves, you can easily be overwhelmed by the very busy interior. The interior is busy only because of the many shapes of other light values. When you are painting value 7 of the leaves, ignore the shapes of the other values. (See the left side of the tree shape that I didn't fill in with values 3 and 1.) You have to learn to ignore the shapes of the other values until you are ready to paint them.

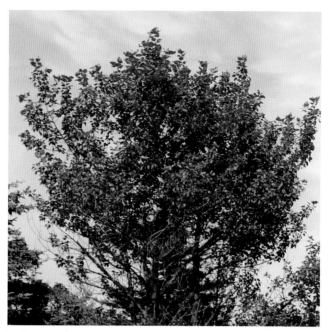

Reference photo

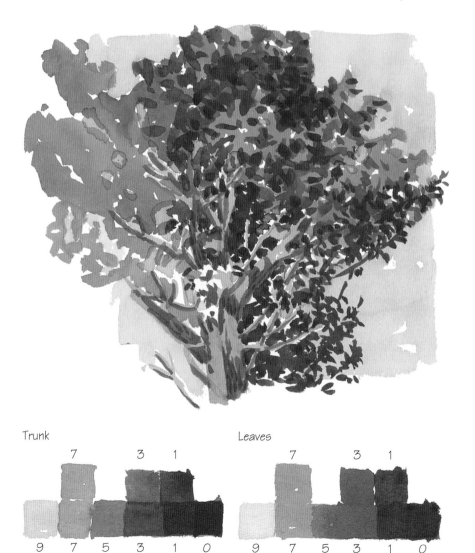

Trunk

	7		3	1	
9	7	5	3	1	0

Leaves

	7		3	1	
9	7	5	3	1	0

Rocks

The rocks in the reference photo are similar to those in the painting, but not exactly the same. Remember that your painted shapes don't have to be a perfect re-creation of what you see. Let your reference guide you, but don't be limited by it.

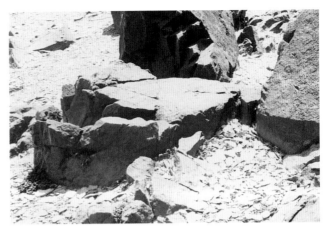

Reference photo

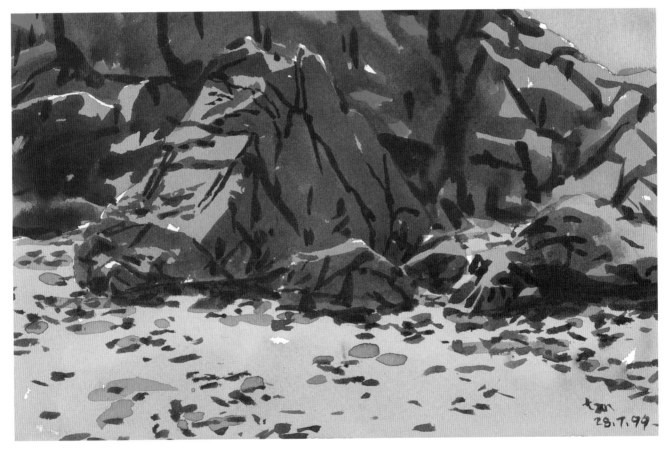

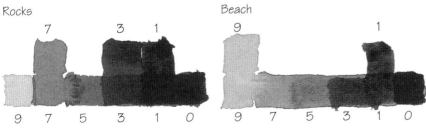

Figure by a Boat

You will notice two things about this painting. First, only a two-step process was used to create the man's skin. This is because two light values were enough to portray that part of the figure. Second, I used a more bluish gray for the shade of the white boat instead of the neutral gray that the value 3 should really be. The bluish gray has the same effect as the neutral gray, but it creates a more colorful painting.

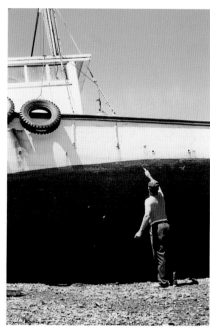

Reference photo

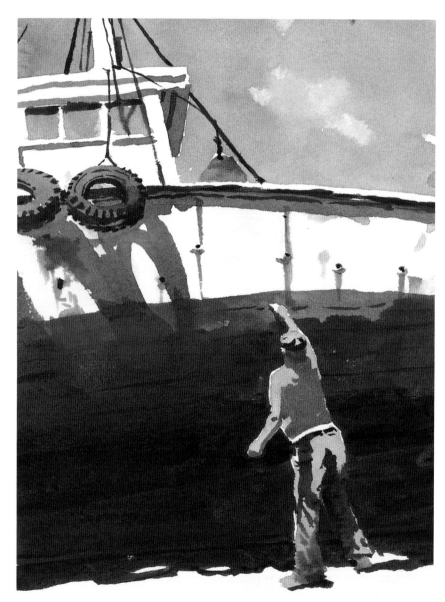

Man's skin

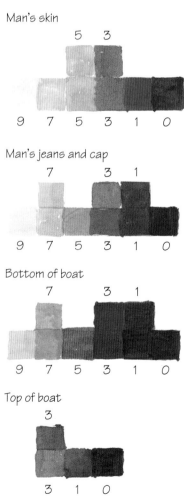

Man's jeans and cap

Bottom of boat

Top of boat

Horses

This was an on-the-spot demonstration, so the painting doesn't exactly match the photo. You have to see the shapes to paint the horses, since they are in position for only a moment. Sometimes you will have to wait for a moving subject to be in the same position again to capture the rest of its shapes. Reading shapes in this way sharpens your perception.

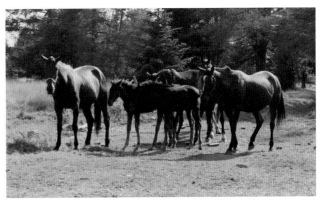

Reference photo

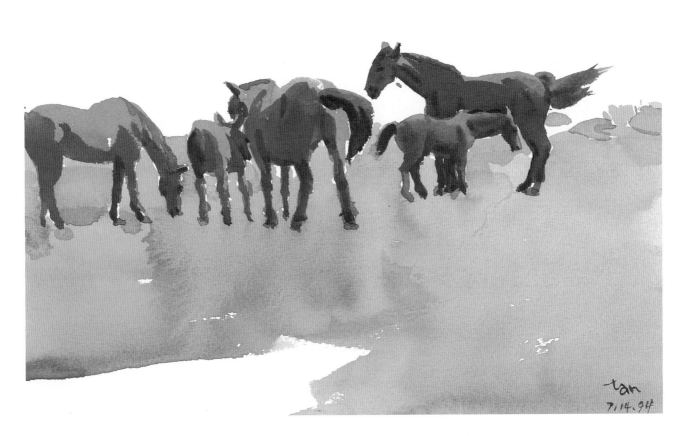

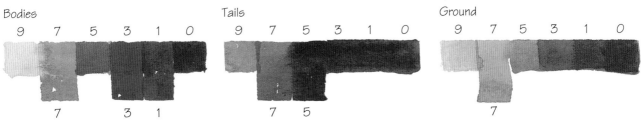

Bodies

9	7	5	3	1	0

7 3 1

Tails

9	7	5	3	1	0

7 5

Ground

9	7	5	3	1	0

7

Water Scene

Although the water in this painting looks fluid, it was painted with all hard-edged shapes, not wet-on-wet as you might have expected. This shows that it is not the technique that creates a subject, but the basic elements of shape and light value. The scales are numbered here to show the order in which some of the elements were painted.

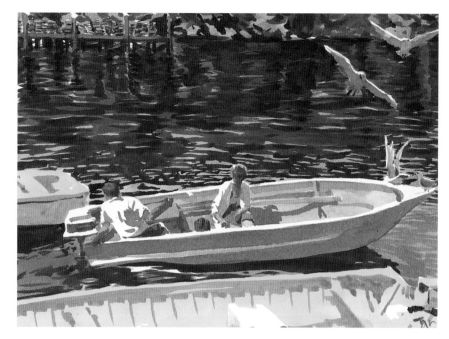

1. Skin

```
9   7   5   3   1   0
        5   3
```

2. Hair

```
9   7   5   3   1   0
        7       3   1
```

3. Man's shirt/woman's sweater

```
        3   1   0
        3
```

4. White boat/sea gulls

```
        3   1   0
        3   1
```

5. Woman's green dress

```
9   7   5   3   1   0
        5       1
```

6. Man's jeans

```
9   7   5   3   1   0
        5   3
```

7. Inside of white boat

```
9   7   5   3   1   0
        7       3   1
```

8. Yellow boat

```
9   7   5   3   1   0
        5   3
```

9. Water/reflections

```
9   7   5   3   1   0
        7   5   3   1   0
```

Boats

This is a very busy and congested scene, full of complex planes, structures, spaces and perspective. My method suggests that all of these elements will create themselves if you just take care of each light value and shape one at a time. The numbers show the order in which the shapes were painted.

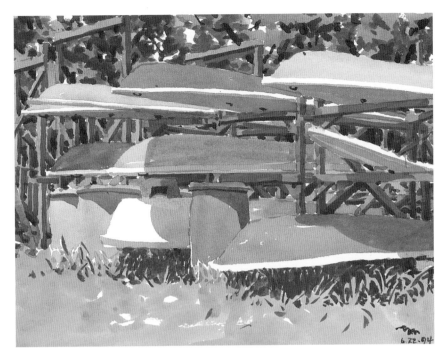

1. Yellow boats

9	7	5	3	1	0

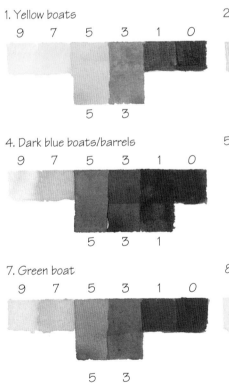

2. Boat racks

9	7	5	3	1	0

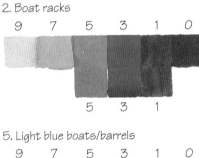

3. White boat

3	1	0

4. Dark blue boats/barrels

9	7	5	3	1	0

5. Light blue boats/barrels

9	7	5	3	1	0

6. Red boat

9	7	5	3	1	0

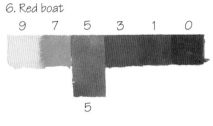

7. Green boat

9	7	5	3	1	0

8. Grass

9	7	5	3	1	0

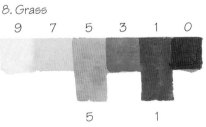

9. Trees

9	7	5	3	1	0

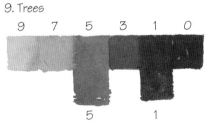

Lighthouse in Fog

The best way to control the subtleties of a fog scene is to paint the value for the fog first to cover all of the paper, and then relate the other shapes to it. This helps you to see, balance and control the subtleties of the values for a unified composition. When you are faced with a question of where to start or what to paint first, the decision should be based on what is easier to see first. The numbers here, as with the examples on pages 56 and 57, indicate the sequence of painting.

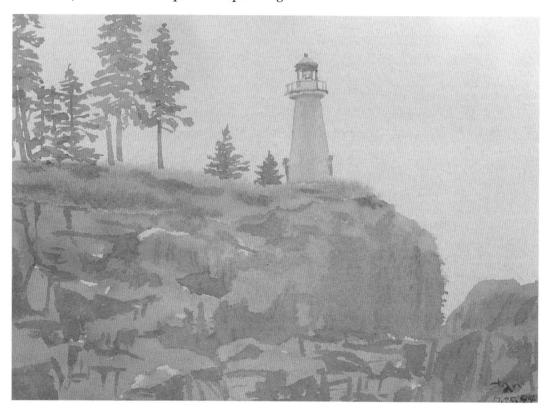

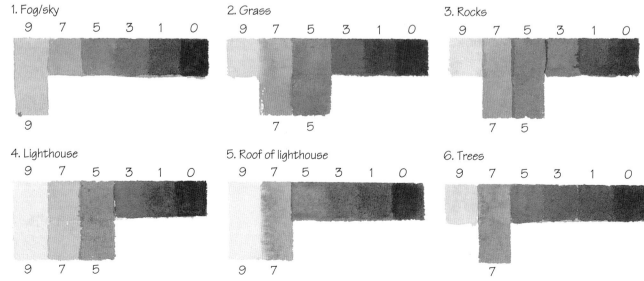

1. Fog/sky

9	7	5	3	1	0

9

2. Grass

9	7	5	3	1	0

7 5

3. Rocks

9	7	5	3	1	0

7 5

4. Lighthouse

9	7	5	3	1	0

9 7 5

5. Roof of lighthouse

9	7	5	3	1	0

9 7

6. Trees

9	7	5	3	1	0

7

Outdoor Scene

For this scene, the trees were severely cropped,
and I changed the hue of the grass for more color.
The house in the background at right was added
to give a sense of scale.

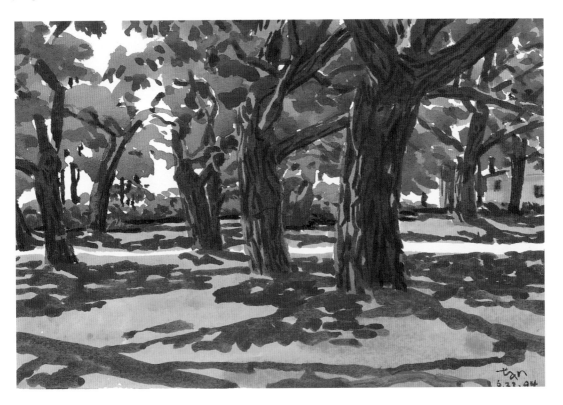

1. Tree trunks

2. Grass

3. Tree leaves

4. Bushes

5. Roof (on house)

6. House

Exercise: Paint a Glass Bottle

At first glance, glass seems like a difficult subject to paint because of all the reflections. Treat it as you would any other subject: shape first, shade next, then detail.

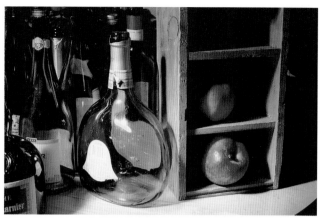

Reference photo

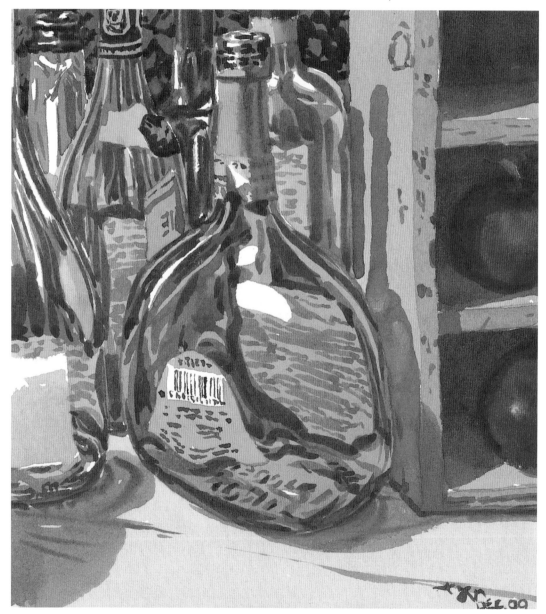

Practice painting the green bottle by following the steps on the next page.

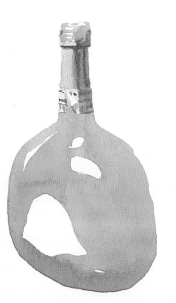

Step 1

Paint the shape of the bottle using value 7. Save white for the label and areas of total reflection of light. Next, paint the ring on the bottle's neck using values 7, 3 and 1.

Step 2

Paint the shade of the bottle with value 3.

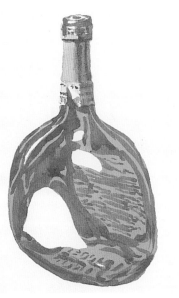

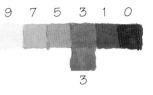

Step 3

Add the details with value 1, then paint the label.

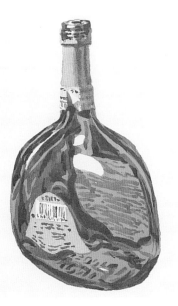

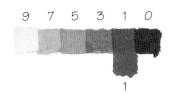

Exercise: Paint a Box

While all subjects can be created using the three values, there are some cases in which four values may be more appropriate. This box is one example: It needs more than three light values to handle the many planes of the box.

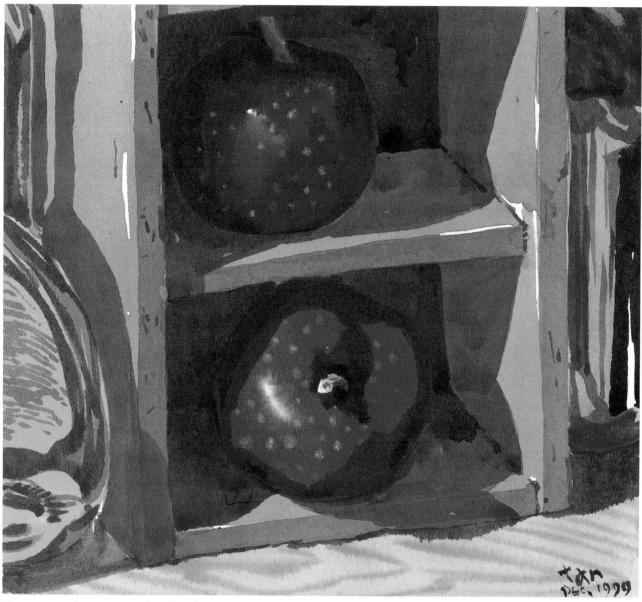

The steps on the next page show how the box in this painting was created.

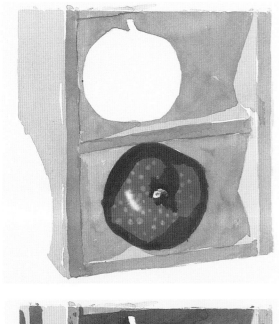

Step 1
Begin by painting the shape of the box with value 7. Paint the edges of the box and start the shadows with value 5.

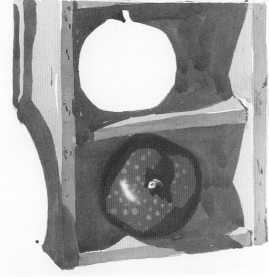

Step 2
With value 3, continue developing the shadows in and around the box. Also use this value to add some nicks to the edges of the box.

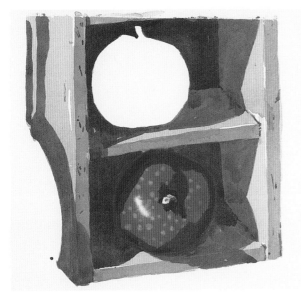

Step 3
Use value 1 to paint the back of the box.

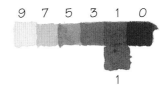

Applying the Three-Step Process 63

Exercise: Paint an Iris

Practice the three-step process to paint an iris like the ones shown below. If you bring flowers indoors to paint, make sure that you light them properly.

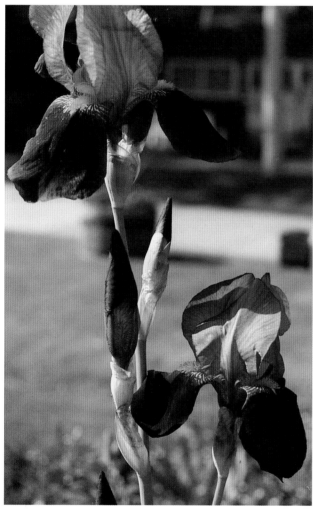

Reference photo

Finished painting

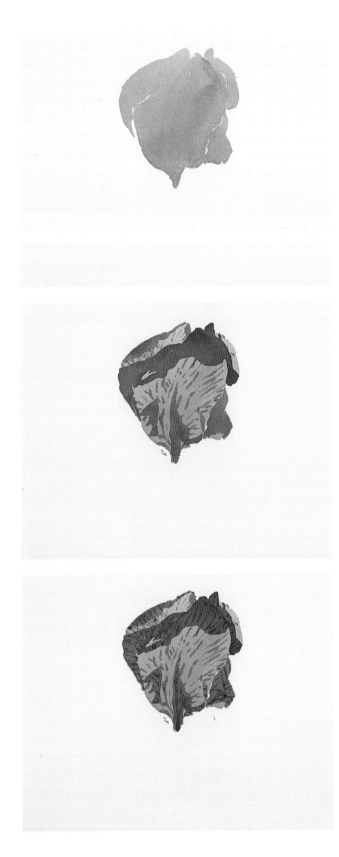

Step 1
Paint the shapes of the top petals with value 7.

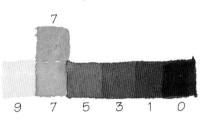

Step 2
Add the petals' shade shapes with value 3.

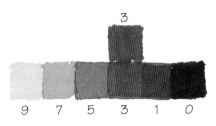

Step 3
Use value 1 to paint the details of the top petals.

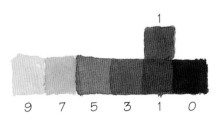

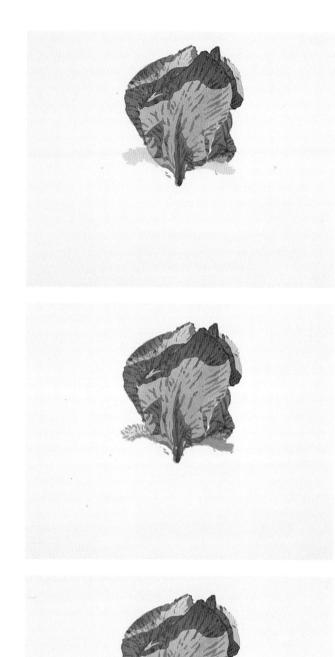

Step 4
Paint the yellow shapes of the iris with value 7.

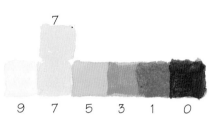

9 7 5 3 1 0

Step 5
Add the shade shapes with value 3.

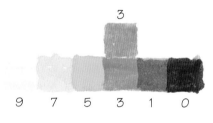

9 7 5 3 1 0

Step 6
Use value 1 to paint the details of the yellow shapes.

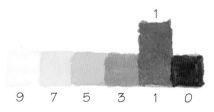

9 7 5 3 1 0

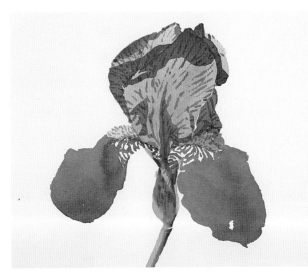

Step 7

Paint the shapes of the lower petals with value 7. The stem was completed with values 7, 3 and 1.

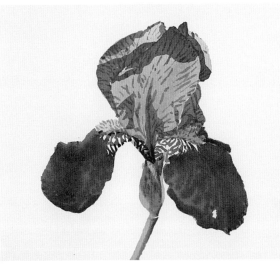

Step 8

Add the shade shapes with value 3.

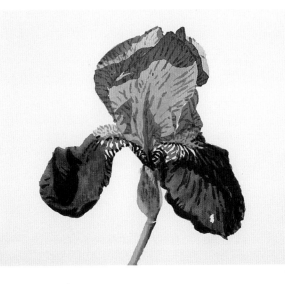

Step 9

Use value 1 to paint the details of the lower petals.

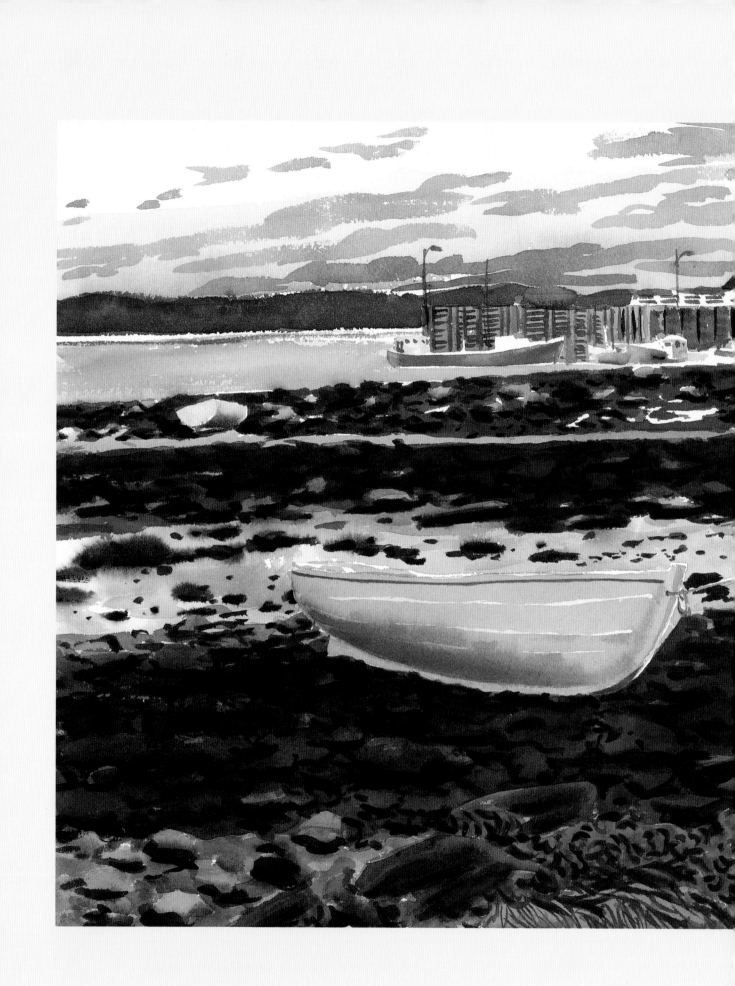

USING HIGHER OR LOWER VALUES FOR DIFFERENT EFFECTS

Higher or lower light values can be used to create the effects that you want. Changing the hue and values used is often necessary to create color contrast and improve color composition. For example, if you want a more intensely colored painting or an impressionistic painting, then start all your shapes with value 5—the most intense color on the value scale—and leave out values 7 and 9, since they are diluted colors. The examples on the following pages show you how to use relative values to create the look you want.

St. Andrews at Dusk
15" × 22" (38cm × 56cm)

Starting With High or Low Values

On the following pages are examples of the same subjects painted with different values. Two paintings are shown for each subject. The first starts with value 7 or 9, the kind of higher light values you see on a sunny day or in bright light. The second painting begins with value 5, which is only seen on a cloudy or overcast day, or in low light. In this case there aren't shade shapes, just a gradual lowering of values. Notice how the difference in value changes the appearance of the subjects.

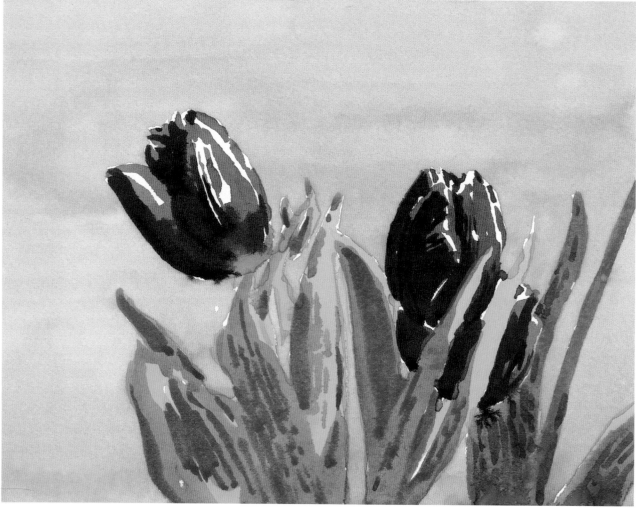

High-value tulips

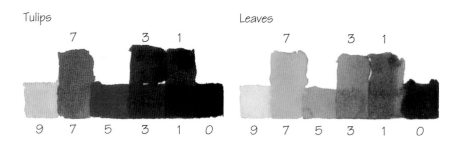

Tulips

7 3 1

9 7 5 3 1 0

Leaves

7 3 1

9 7 5 3 1 0

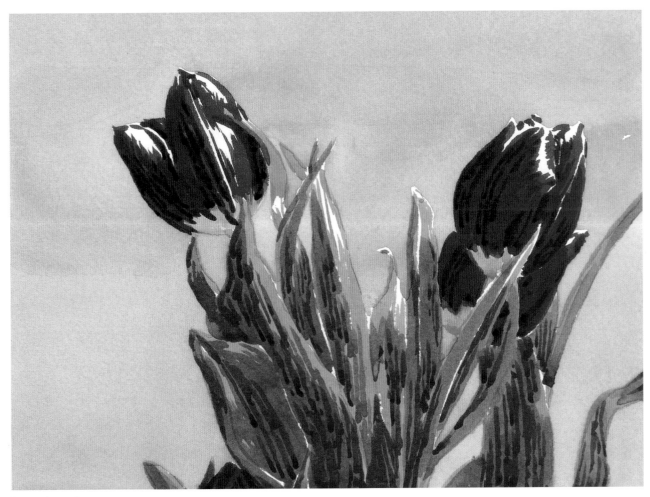

Low-value tulips

Tulips

| | 5 | 3 | 1 | |
| 9 | 7 | 5 | 3 | 1 | 0 |

Yellow shapes of tulips

| | 5 | 3 | | |
| 9 | 7 | 5 | 3 | 1 | 0 |

Leaves

| | 5 | 3 | 1 | |
| 9 | 7 | 5 | 3 | 1 | 0 |

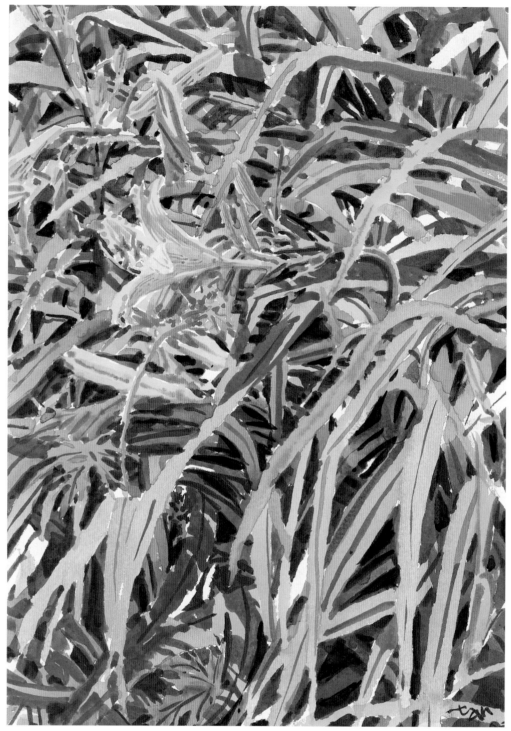

High-value daylilies

Daylilies

9 5 3 1

9 7 5 3 1 0

Wilted daylilies

5 3 1

9 7 5 3 1 0

Leaves

9 7 3 1 0

9 7 5 3 1 0

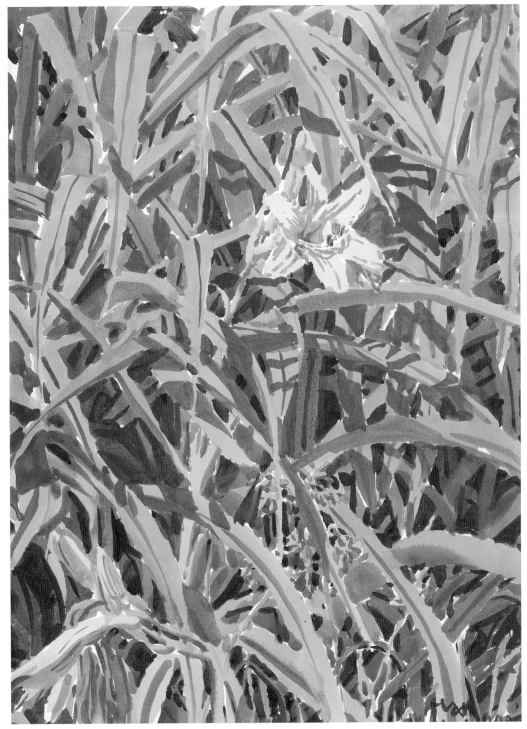

Low-value daylilies

Daylilies

5 3 1

9 7 5 3 1 0

Leaves

5 3 1 0

9 7 5 3 1 0

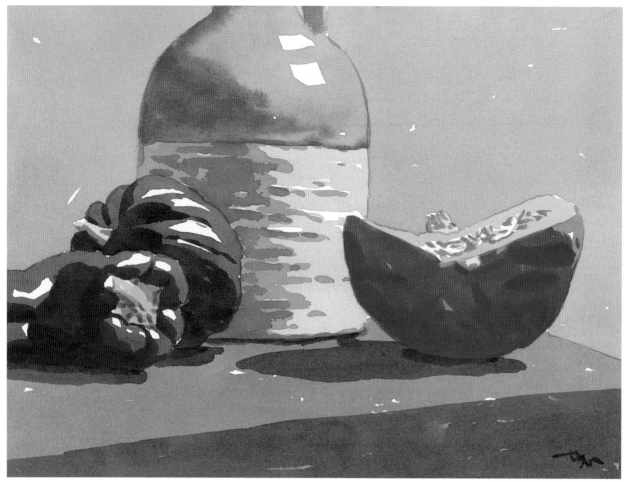

High-value still life

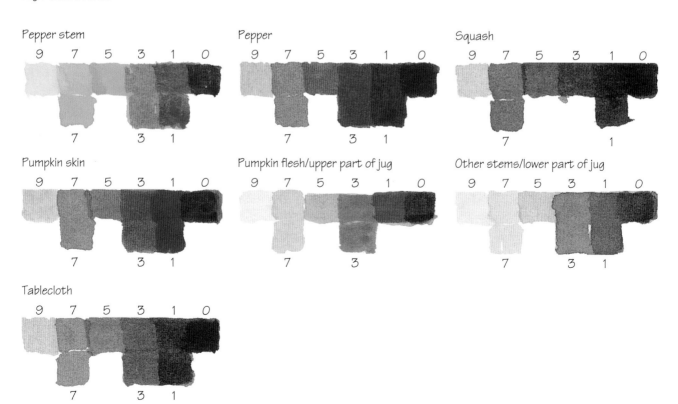

Pepper stem

Pepper

Squash

Pumpkin skin

Pumpkin flesh/upper part of jug

Other stems/lower part of jug

Tablecloth

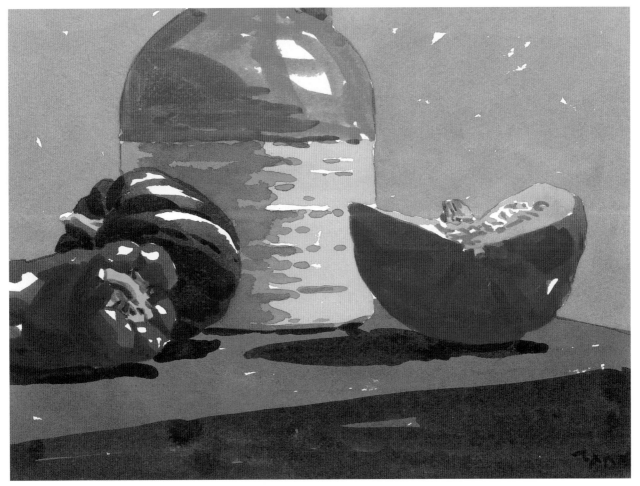

Low-value still life

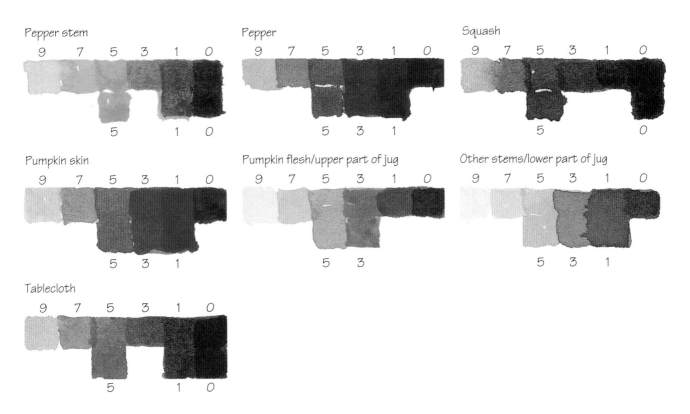

Pepper stem

9	7	5	3	1	0

5		1	0

Pepper

9	7	5	3	1	0

5	3	1

Squash

9	7	5	3	1	0

5	0

Pumpkin skin

9	7	5	3	1	0

5	3	1

Pumpkin flesh/upper part of jug

9	7	5	3	1	0

5	3

Other stems/lower part of jug

9	7	5	3	1	0

5	3	1

Tablecloth

9	7	5	3	1	0

5	1	0

Step-by-Step Demonstration: Landscape in High/Low Values

This demonstration actually shows two ways to paint the same subject, starting with high or low values. Compare the steps for each and note the difference in appearance of the final paintings.

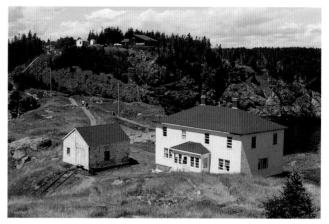

Reference photo

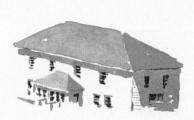

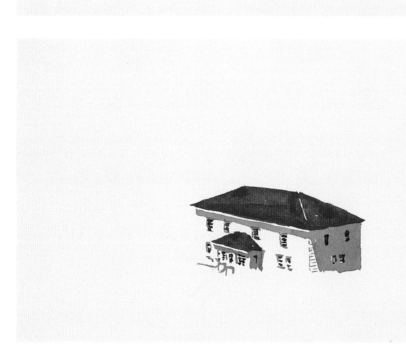

Step 1

Start with the roof of the house. For the higher value painting, use values 9 and 7. For the lower, use value 5. For the house, the same values were used in each painting. For the white shape of the house, simply leave the white of the paper. Use value 3 for the shade and value 0 for the window details.

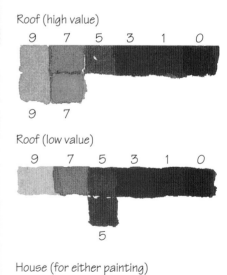

Roof (high value)

9 7 5 3 1 0

9 7

Roof (low value)

9 7 5 3 1 0

5

House (for either painting)

3 1 0

3 0

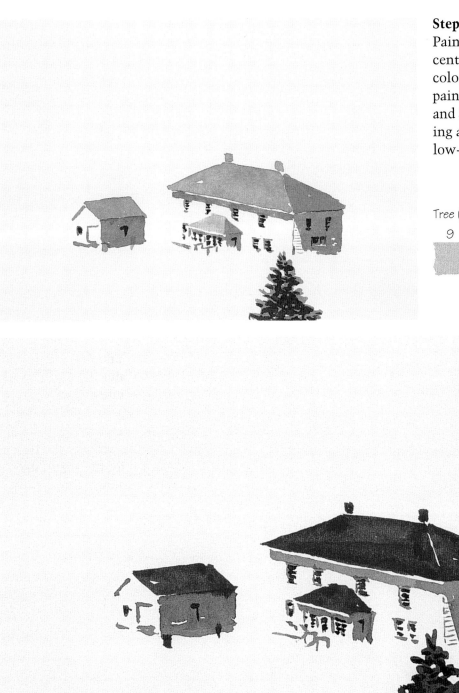

Step 2

Paint the smaller building adjacent to the house with the same colors used for the house. Next paint the tree, using values 7 and 3 for the high-value painting and values 5 and 1 for the low-value one.

Tree (high value)

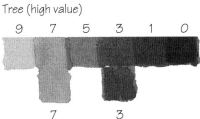

Tree (low value)

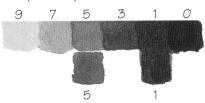

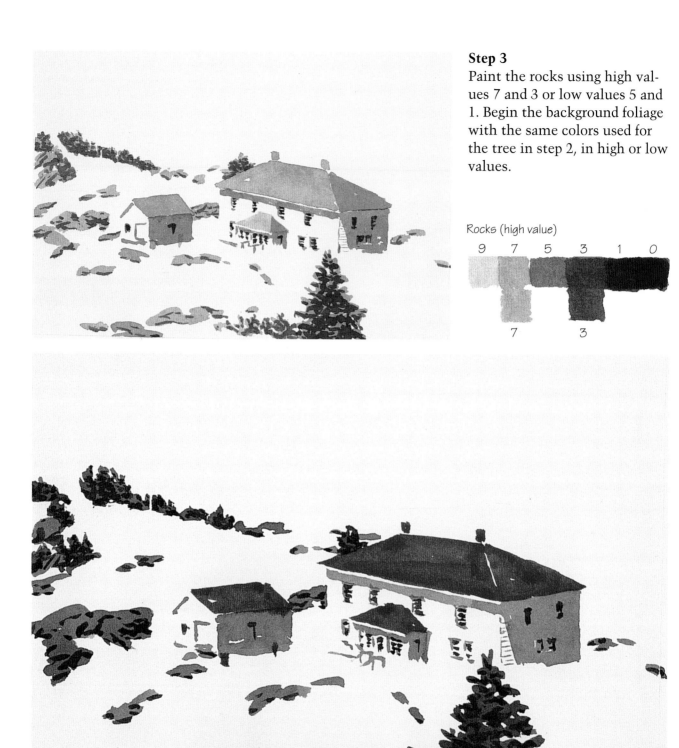

Step 3
Paint the rocks using high values 7 and 3 or low values 5 and 1. Begin the background foliage with the same colors used for the tree in step 2, in high or low values.

Rocks (high value)

9 7 5 3 1 0

7 3

Rocks (low value)

9 7 5 3 1 0

5 1

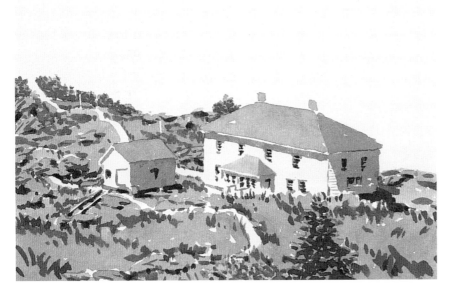

Step 4

Leaving the white of the paper for pathways, paint the dry grasses surrounding the buildings. Use high values (7, 3 and 1) or low values (5, 3 and 1). The dry grasses will define the remaining edges of the buildings.

Dry grasses (high value)

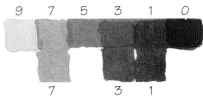

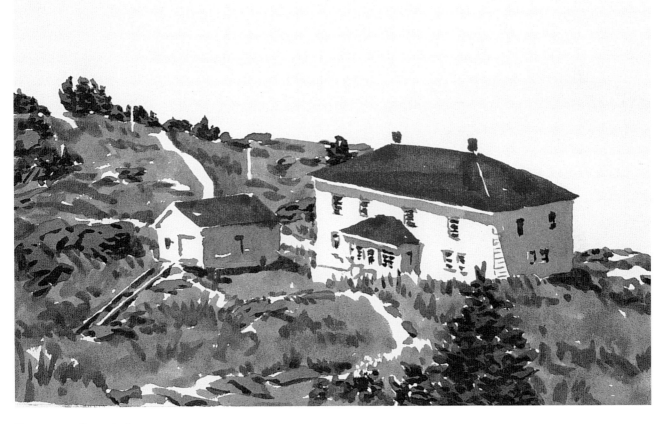

Dry grasses (low value)

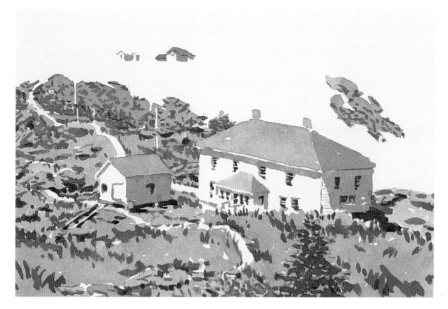

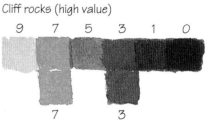

Step 5

Paint the roof of the house in the distance with value 5 for either painting. Paint the distant house with the same values as used for the buildings in step 1. Paint the cliff rocks next, using values 7 and 3 or 5 and 1.

Cliff rocks (high value)

9	7	5	3	1	0

7 3

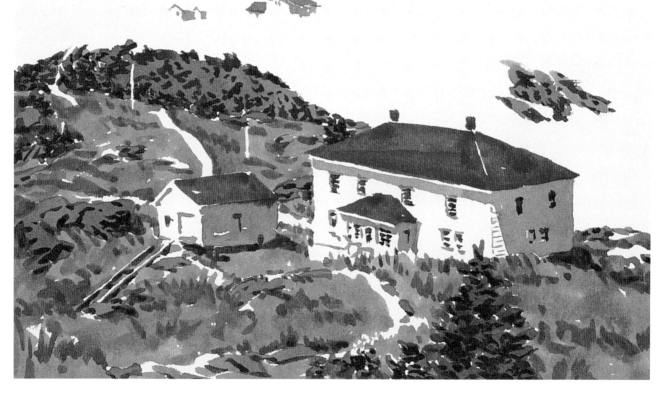

Distant roof (for either painting)

9	7	5	3	1	0

5

Cliff rocks (low value)

9	7	5	3	1	0

5 1

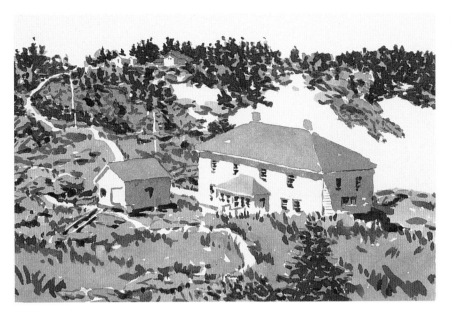

Step 6
Add more dry grass and foliage in the distance with the values used in steps 2 and 4.

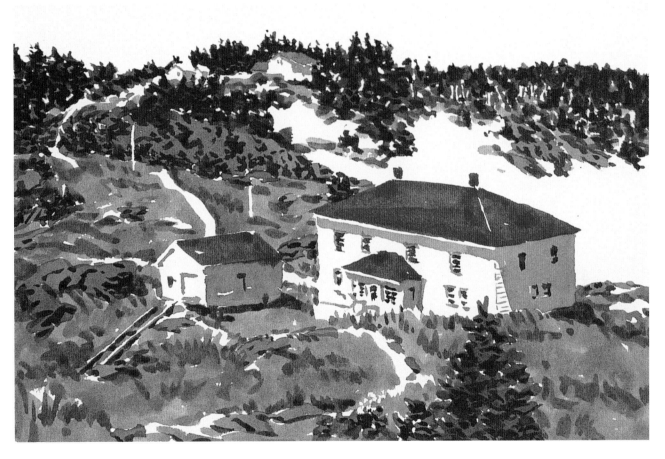

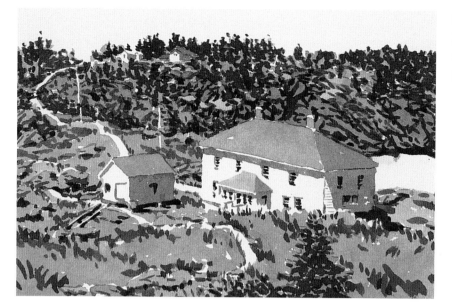

Step 7
Finish the cliffs with the values used in step 3 for the foreground rocks.

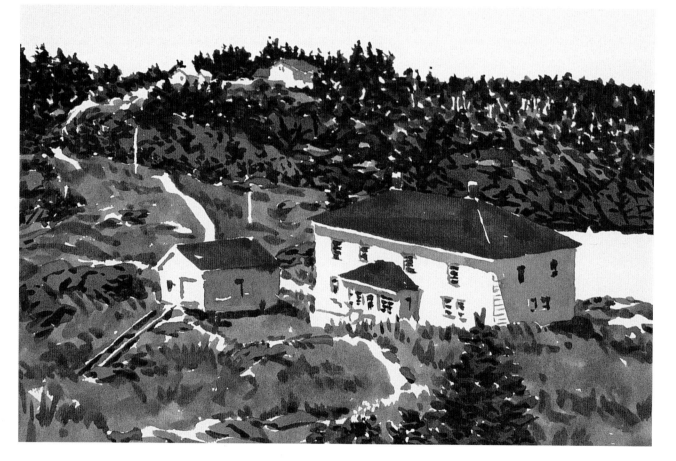

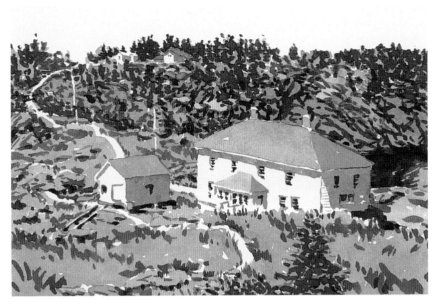

Step 8

Add the water near the house starting with high value 7 or low value 5.

Water (high value)

9	7	5	3	1	0

7 3 1

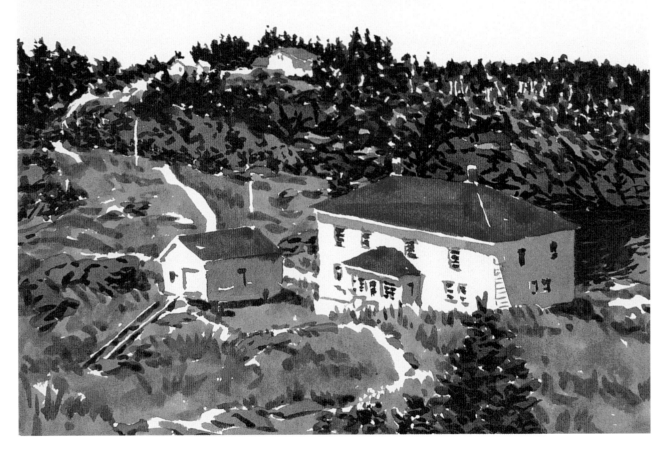

Water (low value)

9	7	5	3	1	0

5 3 1

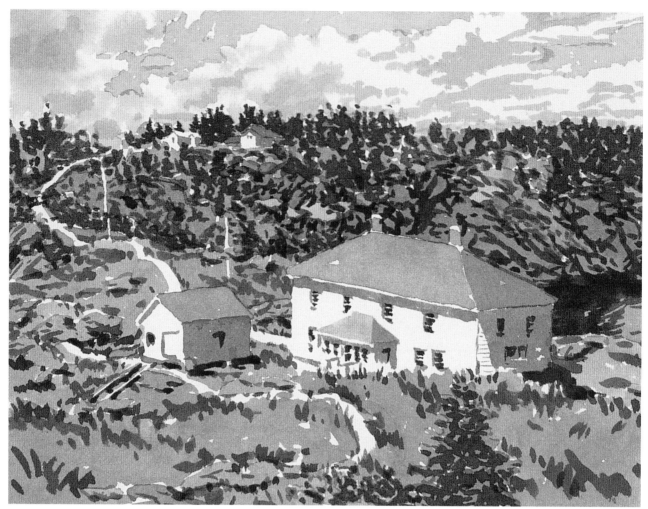

Step 9

Paint the exposed sky first to define the cloud shapes, using value 7
or 5. Then paint the clouds. In the high-value painting, only use the
white of your paper and value 3. In the low-value painting, use val-
ues 3 and 1. Compare the high-value finished painting above with
the low-value version on the next page.

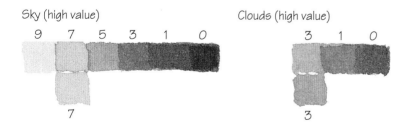

Sky (high value)

9 7 5 3 1 0

7

Clouds (high value)

3 1 0

3

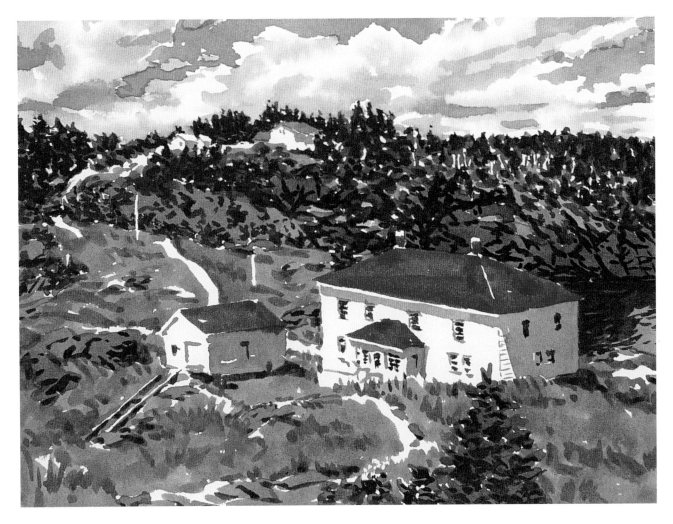

Sky (low value)

9 7 5 3 1 0

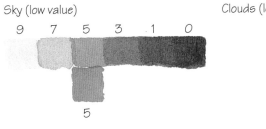

5

Clouds (low value)

3 1 0

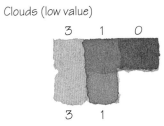

3 1

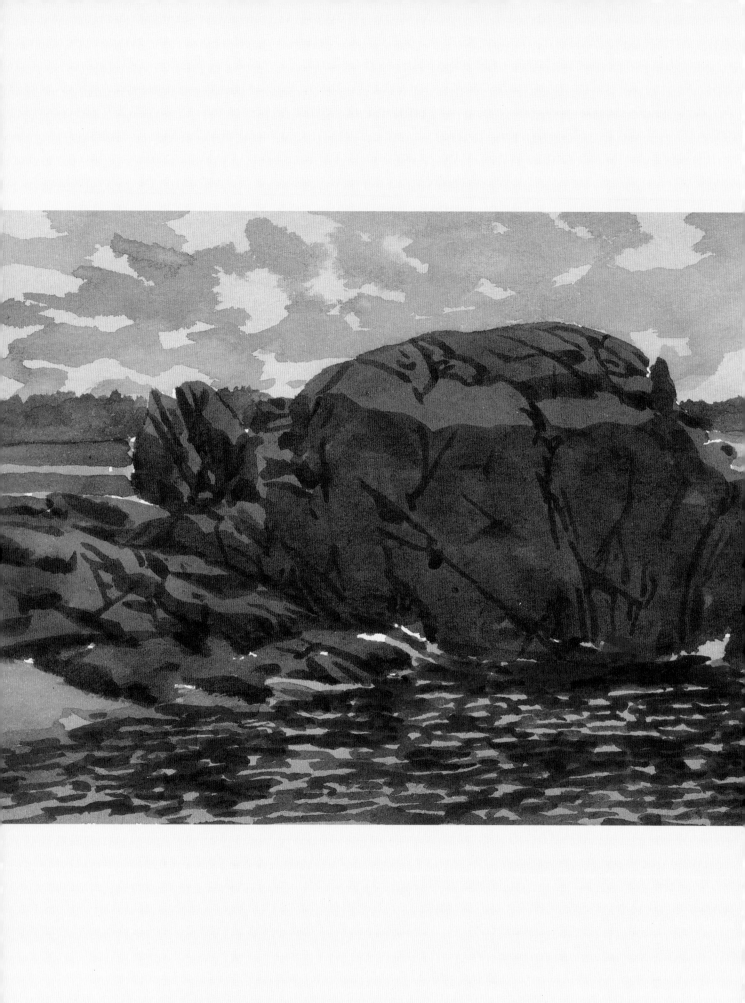

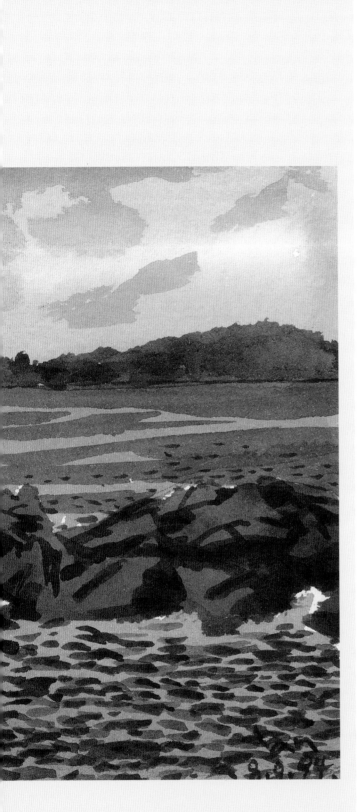

6

COMPOSITION THE EASY WAY

What does composition mean? Composition is the arrangement of shapes and light values within a frame of reference. A composition is arranged by cropping an area of your subject to paint. This is carried out before you begin mixing light values and painting shapes. A good composition makes a world of difference to the quality of a painting. Elements that are needed for a good composition are contrast, balance and harmony of shapes and light values (colors). In the final analysis, rely on what pleases your eye when you compose or crop your painting target.

Rocks
4" × 7¾" (10cm × 20cm)

Contrast Shapes and Light Values

Using what you know about the basic elements of shapes and values, you can create a good composition. Look for contrast between shapes—the light and shade shapes, the positive and negative shapes. Positive shapes are the objects themselves and negative shapes are the spaces around those objects, including the background. A good composition has an interesting variety of shapes ranging from small to large and from regular to irregular; shapes that are horizontal, diagonal and vertical.

You should also look for the contrast of light values—a balance of high values (5, 7, 9 and 10) and low values (3, 1 and 0). The contrast between high and low values—which create the elements of light, shade, plane, structure, form and space—helps to develop a strong composition. A painting without high and low light values is a painting with ambiguous elements or features. Contrasting light values also create an evocative and exciting color composition, because all light values are also colors themselves.

Avoid repetition of shapes and values as much as possible, as redundancy can create passive energy and monotony in a painting. Remember, these are things to look for only; there is no rigid formula you can follow. To develop an intuitive sense of good composition, focus on shapes and light values and learn to trust your eye. The same eye that recognizes good paintings will also help you create good paintings.

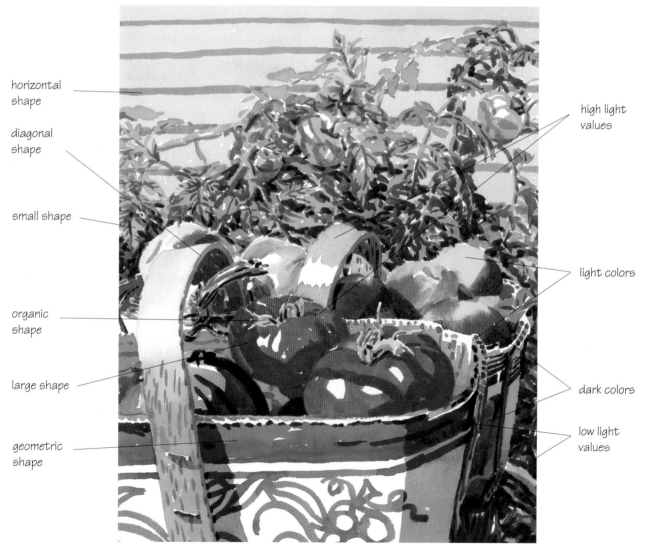

horizontal shape

diagonal shape

small shape

organic shape

large shape

geometric shape

high light values

light colors

dark colors

low light values

Three specific compositional elements that make this painting a good one are the variety of shapes, the contrast of light values and the contrast of colors.

Light Your Subject Correctly

Light is the primary provider of the contrast of values and shapes. With proper lighting, you'll see a variety of interesting shapes and values in any subject.

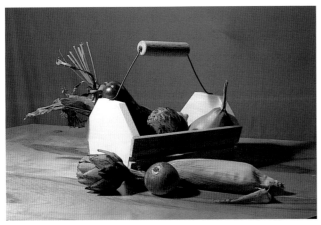

Light your subject from the left side . . .

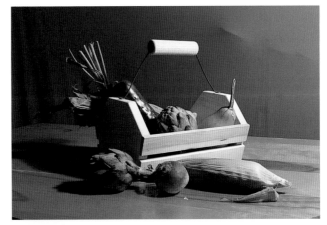

. . . the right side . . .

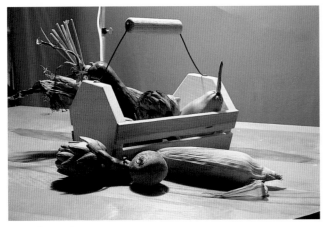

. . . or from the top . . .

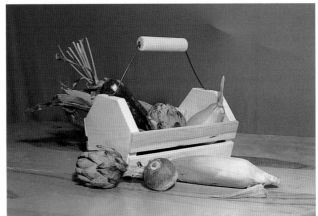

. . . but never light your subject from behind you! All of your subject will be in high light, creating no contrast in values.

Tip
Do not light your subject with more than one light source. They will cancel out each other's shade shapes, creating conflicting planes, shadows and reflected light. You will get caught up in trying to manipulate all of the subtle light values that result.

Build Composition Around First Shape

Your composition is determined by the scale and placement of the first shape you paint. When you place and scale the first shape correctly, you will crop exactly where you have intended. Relate all other shapes to the first in scale and there will be no need for sketching.

To transfer your concept to paper, simply visualize an imaginary frame around your subject to locate its edges for cropping. Choose a central shape as the first one to paint. After painting your first shape, choose a second shape that shares a boundary with the first. Repeat with each shape in your frame until your painting is finished. To keep everything in proportion, see peripherally while you paint to relate the shape you are painting to what you've already painted.

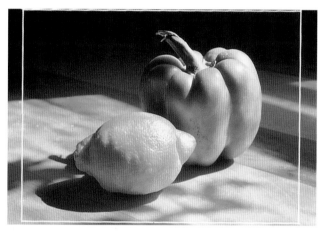

For this composition, indicated by the white frame, I painted the lemon shape first.

Visualize or relate the lemon shape to the rectangle of your paper to determine its scale and placement.

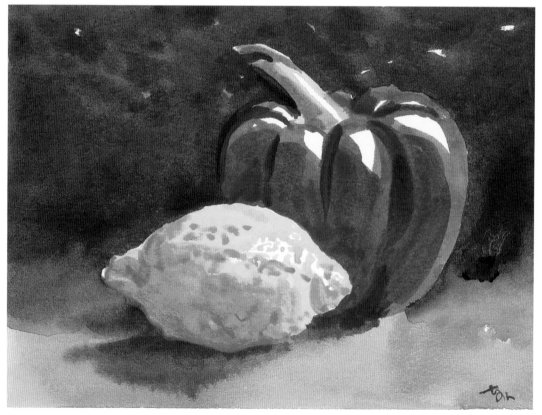

Finished composition

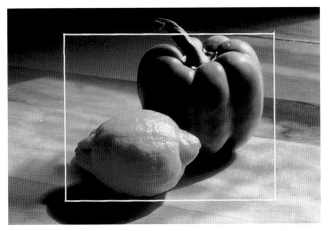

This reference photo is almost identical to the one on the previous page, but this time I cropped more closely.

Again, relate the lemon shape to the rectangle of your paper, in placement and scale.

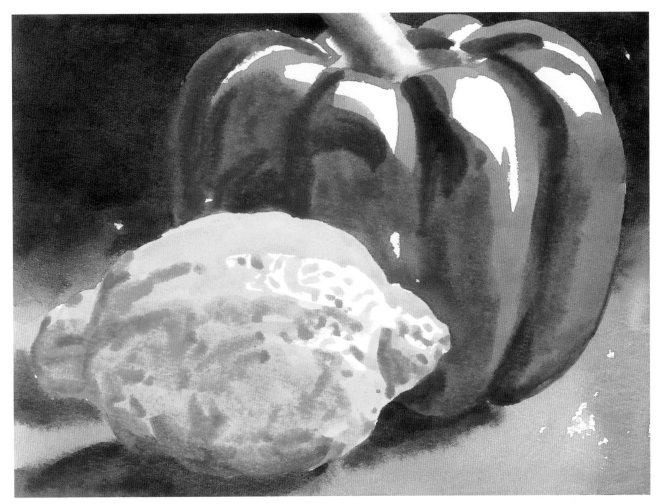

Finished composition

Tip

Learn to crop your subjects by eye only. Some artists use tools to help them decide on a composition. I don't recommend using these tools, however, because you should learn how to scale intuitively. Intuitive scaling removes inhibitions and allows you to paint with confidence.

In this reference photo, the large rock on the left in the middle ground is the first shape painted in each of the compositions below.

Rock shape cropped wide

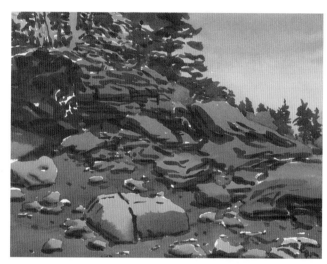

Finished composition

Rock shape cropped close

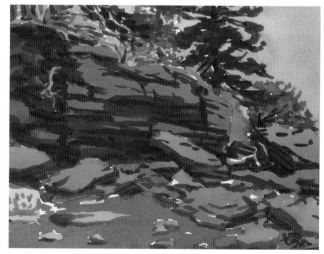

Finished composition

Cropped reference photo

First painted shape

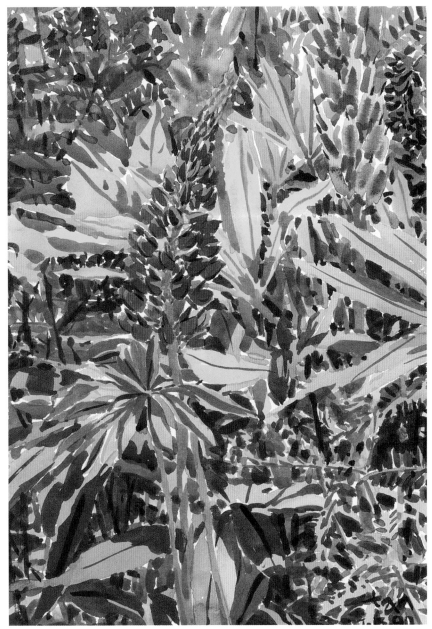

Finished composition

Crop Out Uninteresting Details

Generally, an artist often takes in too much of a subject, seeing like a tourist documenting a trip. Include only the parts of a scene that contain interesting light values and shapes.

This reference photo and the painting below illustrate an example of cropping out unnecessary details for a better composition. I wanted the focus to be on the group of boats on the shore, so details such as power lines and most of the foliage were cropped out.

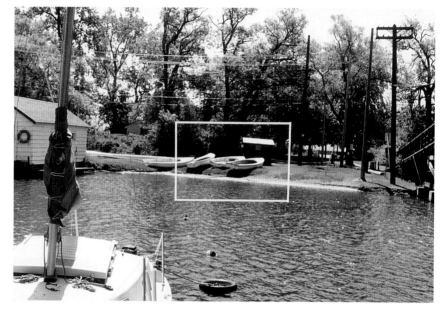

The Canada geese were not intended to be a part of the composition. As I was demonstrating painting to my students the geese came along, so I took the opportunity to show how easy it is to paint moving objects when you see them as shapes. The geese definitely improve the composition, adding interesting vertical and round shapes to the horizontal waves. They also add the highest and lowest light values to that area.

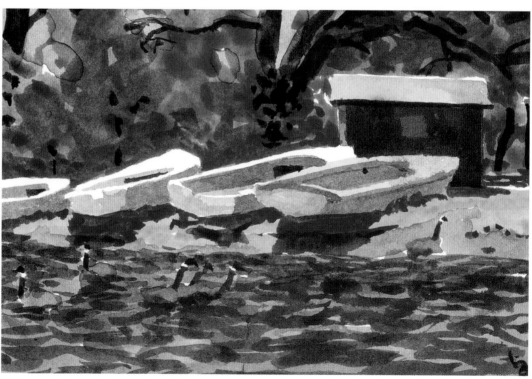

Move Objects to Create Different Arrangements

Don't hesitate to move shapes around to create the composition you want. Don't think too much when deciding on a composition for a painting. The easiest way to come up with a great arrangement is to randomly place the shapes and let your eye spot it. You can move still life objects easily; you can also shift the location of a tree, rock or house in your painting if you feel it will improve your composition. Remember, a composition works because of the basic elements—shapes and light values.

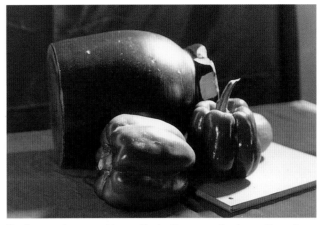

Don't crowd your subjects like in the example above. Crowding creates a mass with no movement, rhythm or spacing. You are more likely to end up with this kind of arrangement if you think too much when placing the objects.

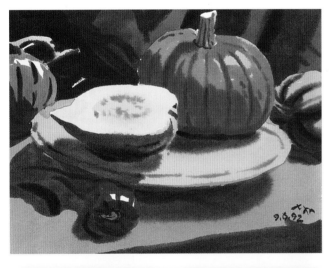

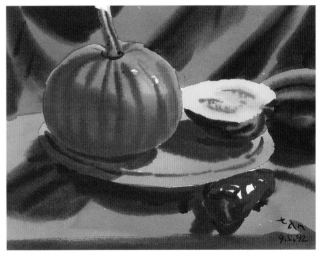

Here I have demonstrated how a collection of shapes can be rearranged to create three equally interesting compositions.

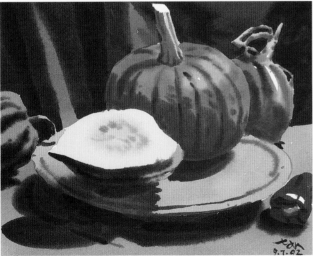

Exercise: Paint a Closely Cropped Lemon and Pepper

Use the cropped composition in the reference photo at right to practice the three-step painting process.

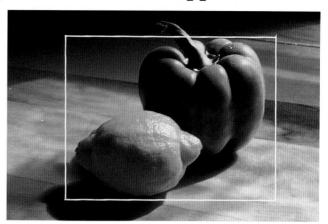

Cropped reference photo

Step 1
Place the lemon shape first using value 5.

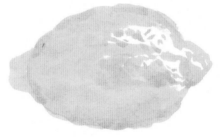

Step 2
Add shade shapes with value 3.

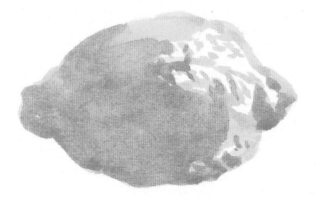

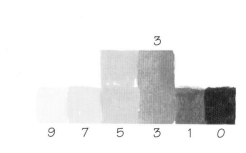

Step 3
Add shade details with value 1.
This completes the lemon
shape.

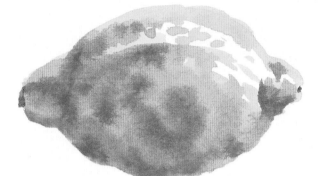

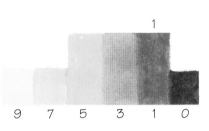

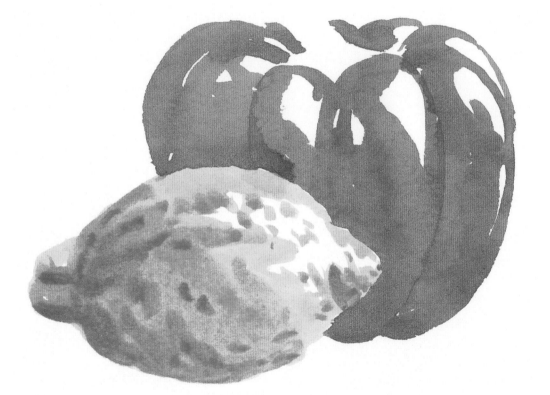

Step 4
Paint the shape of the pepper with value 5. Start
at the shared boundary.

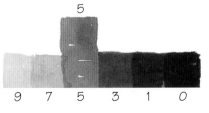

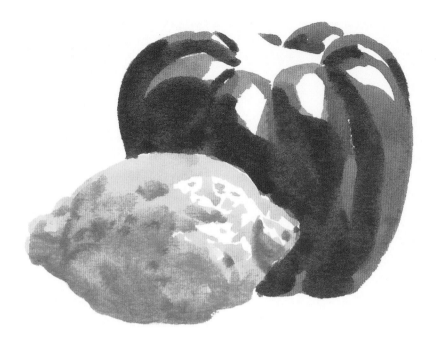

Step 5
Add shade shapes on the pepper with value 1.

Step 6
Add shade details on the pepper with value 0. Repeat the 3-step process for the pepper's stem—use value 7 for shape, 3 for shading and 1 for detail.

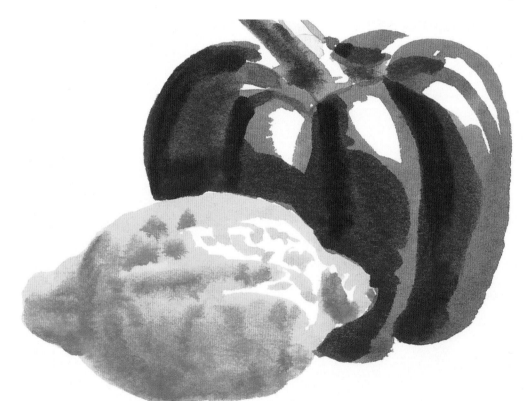

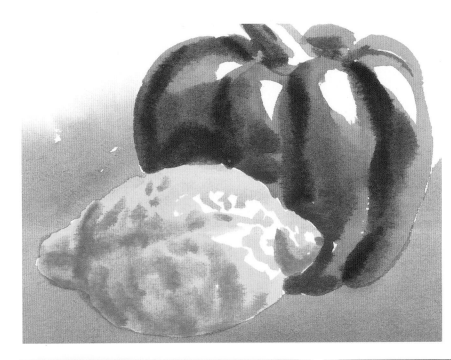

Step 7
Paint the table part of the background with value 5.

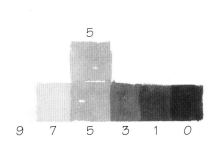

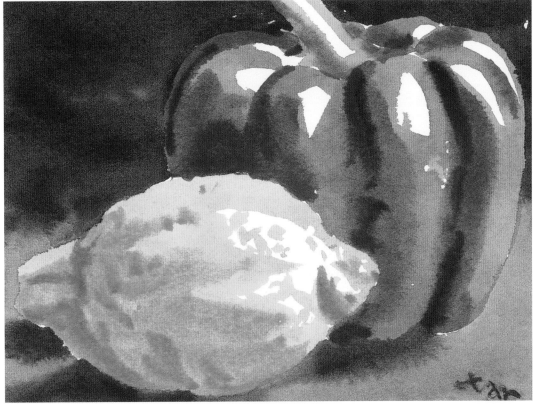

Step 8
Finish the background and paint the shadows cast from the lemon and pepper using values 1 and 0.

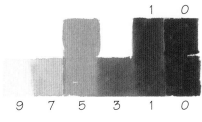

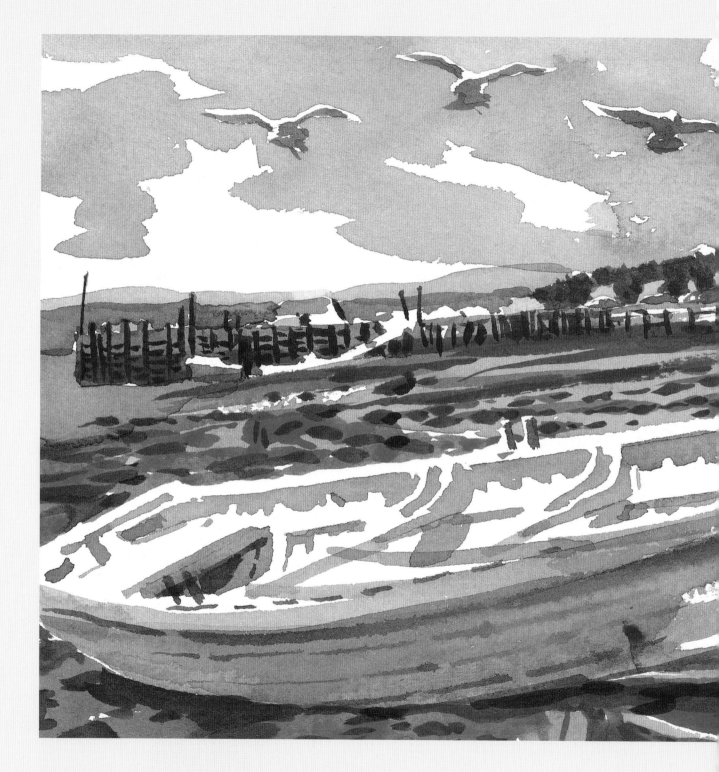

7

STEP-BY-STEP DEMONSTRATIONS

This method of painting in watercolor is very much a step-by-step process. You begin by cropping a scene for your composition. Then you place the first shape with the right scale in order to crop at the spot you have selected. You paint each shape completely, in most cases, before moving on to another. The completed shapes offer good visual reference to help you paint the next shape to scale and use the proper light values; they also help you arrange a better color composition. You couldn't use unfinished shapes for any of these purposes.

Your temptation to want to paint all over the paper is normal. You can't paint everything at once, so learn to relax and focus on the shape you are painting. There are exceptions of course; for example, a wet-on-wet painting requires you to almost simultaneously paint all the shapes before any of them dry to keep the edges soft. In this chapter, you will practice focusing on the shape you are painting and ignoring all other shapes until you are ready to paint them.

Boat and Sea Gulls
5" × 8" (13cm × 20cm)

Step by Step: Black-Eyed Susans

In this step-by-step demonstration, note how the composition is cropped from a wider scene to reduce the size of the background. The first shape you will paint is the cone of the largest flower. Every other shape will relate back to this cone in scale and placement. You will use peripheral seeing—moving your eyes from the shape being painted to the shapes already painted—to keep the painting in proportion and to keep shapes in their proper relation to one another.

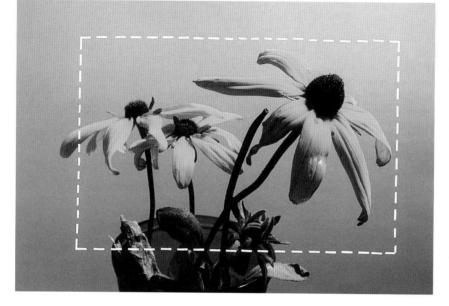

REFERENCE PHOTO
Crop your subject for the composition you want. Here, I cropped to reduce the size of the background for a better composition.

Step 1
Scale and place the first shape, the cone of the foreground flower, to match your cropped composition. Paint the shape with value 7. Add value 3 to cover most of the shape, leaving a little narrow shape in value 7 for a highlight. (Follow the mixing guide and light value scale below.)

Proportion of pigments used to mix values 7 and 3 of the cone.

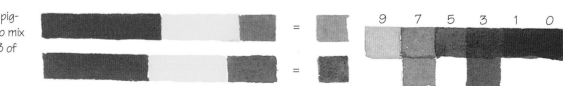

For the next three steps, focus on the foreground flower only.

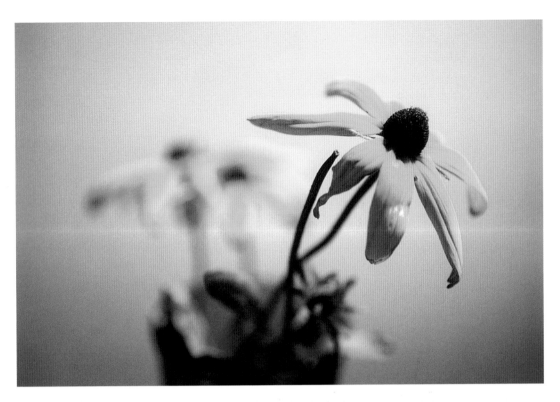

Step 2
Mix value 5 to paint the flower's shape. Focus on the petals shape by shape, ignoring all the subjects around it. Don't worry about the other light values of the petals at this point; just lay down the flower's overall shape.

Proportion of pigments used to mix value 5 of the petals.

9 7 5 3 1 0

5

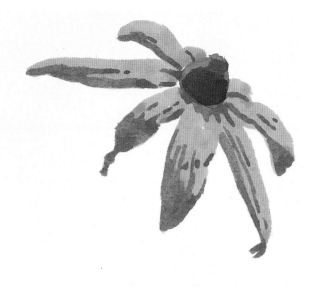

Step 3
Mix value 3 to paint the shade shapes of the petals.

Proportion of pigments used to mix value 3 of the petals.

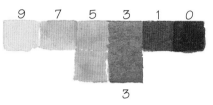

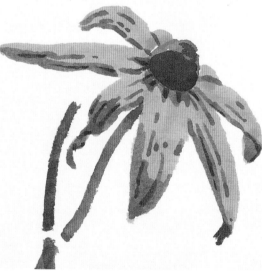

Step 4
Mix value 1 to create the details of the petals. This completes the foreground flower. Use value 3 to paint the stems, paying attention to the negative space around them.

Proportion of pigments used to mix value 1 of the petals and value 3 of the stems.

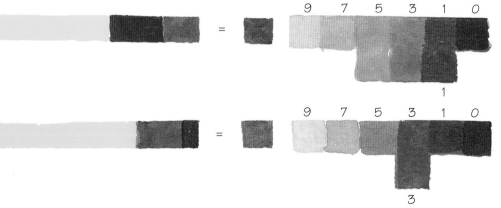

Now focus on the two flowers in the background.

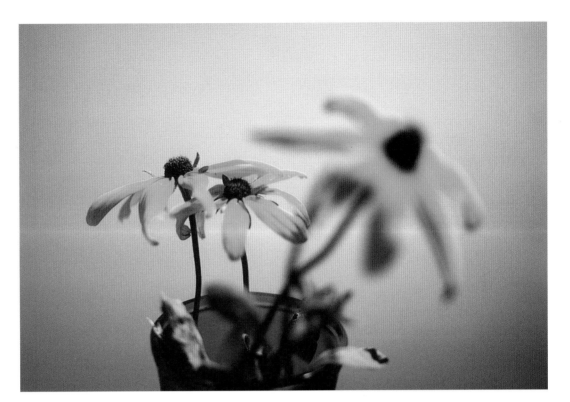

Step 5
Focus on the background flower on the right. Using the same value 7 that was used for the first cone, paint the cone shape first, relating it to the first cone for scale and placement.

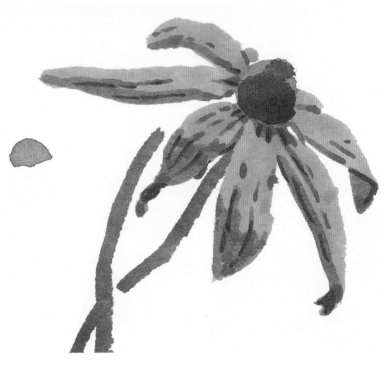

Tip
Don't waste much time trying to paint shapes perfectly. Should you place them incorrectly, let it be and move on. Making mistakes is part of the learning process.

Step 6

Complete the cone on the middle flower with value 3 to create the shade. Then, using value 5 in yellow, relate the petals to the cone shape by shape in order to foreshorten and paint them in proper proportion and perspective. Ignore the other light values in the petals until you are ready to paint them. Paint the shapes of the flower on the far left in the same manner.

Step 7

Complete the shading on the far-left cone with value 3. Use yellow value 3 to add shading to the flowers, and then move on to the details of the petals, using yellow value 1.

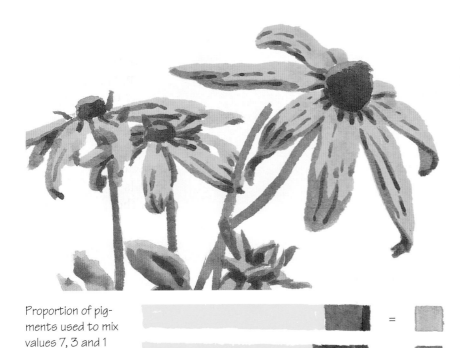

Step 8

Look at the negative shapes to paint the stems and leaves. See peripherally to keep yourself from painting out of scale. Use value 3 for the stems; then use values 7, 3 and 1 to paint the leaves, in that order.

Proportion of pigments used to mix values 7, 3 and 1 of the stems and leaves.

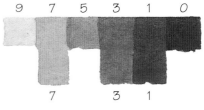

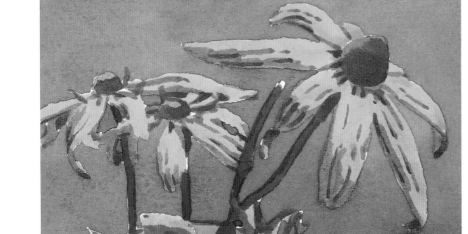

Step 9

Paint the vase using values 7 and 3. Finally, add the background color to complete the painting. I used a value 5 which is high; that is why the contrast is subtle. If you want the flowers to stand out more, use a value 3 or 1, or use a complementary color. (To make the stems more like the reference photo, I painted over them with value 1.)

Proportion of pigments used to mix values 7 and 3 of the vase.

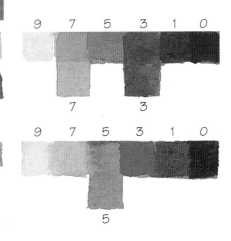

Proportion of pigments used to mix value 5 for the background.

Step by Step: Still Life

When painting objects in a bowl, basket or other container, always paint the objects first, for two reasons. First, it is easier to see to paint the objects and relate the bowl to them. Second, if the bowl is painted first and the shape is too wide or too narrow, the objects won't sit well on it.

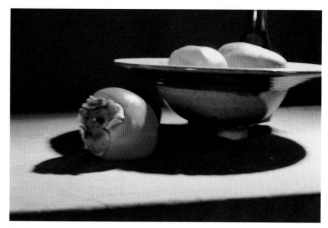

Reference photo

Steps 1 and 2

Paint the pear shapes first using value 5 of yellow and green. Leave the white of the paper for high reflection areas. Next add the shade areas with value 3 in each color.

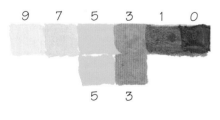

9 7 5 3 1 0

5 3

Proportion of pigments used to mix values for the yellow part of the pears.

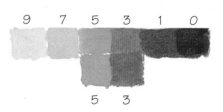

9 7 5 3 1 0

5 3

Proportion of pigments used to mix values for the green part of the pears.

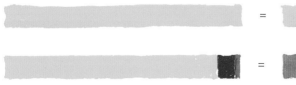

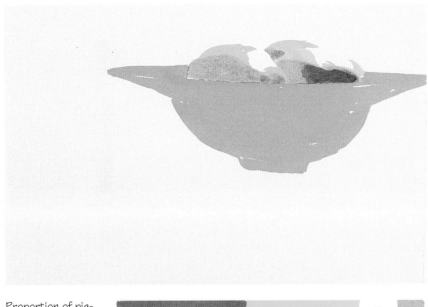

Step 3

Use value 7 of bluish green to paint the shape of the bowl. Relate the shape you are painting to the pears you've already painted. Remember to focus on the shape, not the edges.

Proportion of pigments used to mix values 7, 3 and 1 of the bowl for steps 3 and 4.

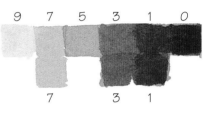

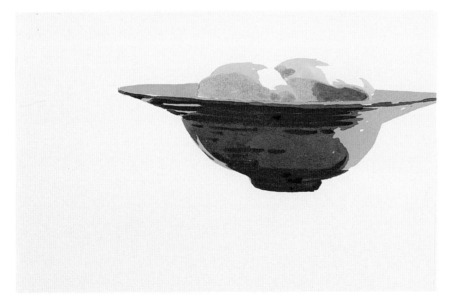

Step 4

Use values 3 and 1 to complete the shade and detail of the bowl. Leave the reflected light shape on the left side of the bowl in value 7 for now; later you will paint over it to show the table reflection.

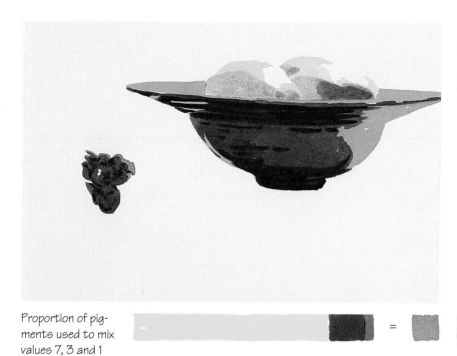

Step 5
The next shape that is easy to see first is the stem of the persimmon. Use values 7, 3 and 1 to paint it.

Proportion of pigments used to mix values 7, 3 and 1 of the persimmon stem.

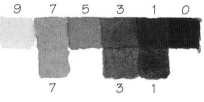

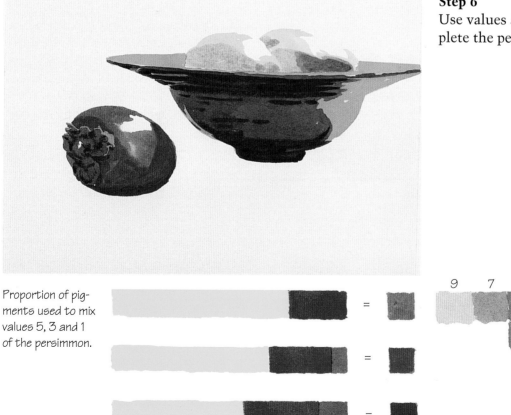

Step 6
Use values 5, 3 and 1 to complete the persimmon.

Proportion of pigments used to mix values 5, 3 and 1 of the persimmon.

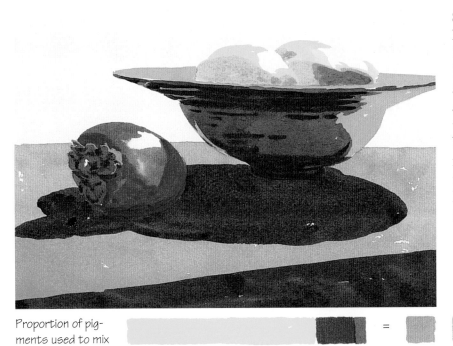

Step 7
Paint the table shape with value 7. A lot of light hits it, so value 7 is more appropriate than value 5. To show high contrast of light and shade, use value 1 to paint the table edge and shadows cast by the bowl and persimmon. As mentioned in step 4, indicate the reflection of the table on the left side of the bowl with value 9 of the table color.

Proportion of pigments used to mix values 7 and 1 of the table.

9 7 5 3 1 0

7

1

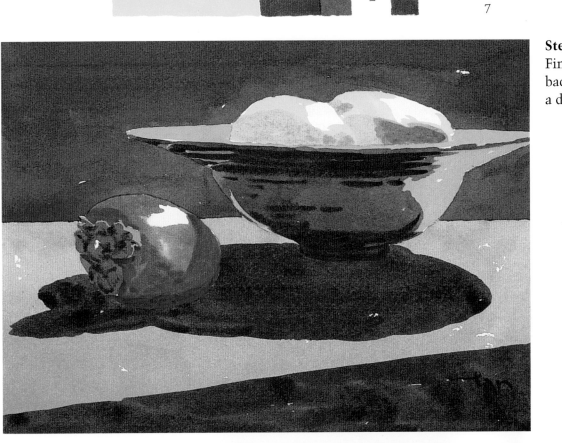

Step 8
Finish the background in a deep blue.

Proportion of pigments used to mix the background color.

=

Step by Step: Water Scene

You might think water and its reflections are difficult to paint. However, if you see them as shapes and light values, the task of painting them becomes just like any other. Once you have learned to see shapes and mix light values, you can paint anything in front of you. The fol-

lowing steps show you the order in which the subjects should be painted. You can start with the boat shapes first if you like, but I find it easier to paint the boats around the figure than the other way around. Paint what is easier to see first.

REFERENCE PHOTO
When deciding on the composition for your painting, add or subtract details as you see fit. In this example, sea gulls were added to enliven the painting.

Step 1
Scale and place the first shape, the man's head, using values 7, 3 and 1. (These values are also used to complete the arms as shown in the next step.) Mix a deeper brown for the man's hair and sunglasses.

Proportion of pigments used to mix the values of the man's skin.

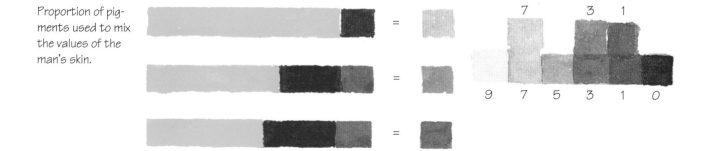

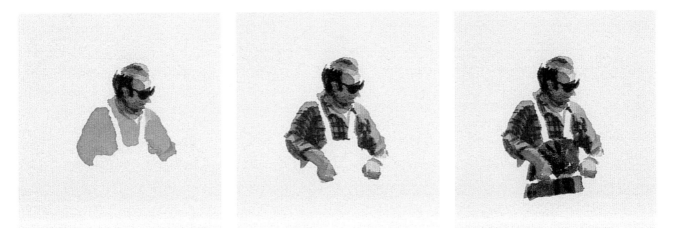

Step 2

Use values 7, 3 and 1 of the blue below to paint the man's shirt. Instead of painting beige suspenders as shown in the reference photo, I painted around the shapes to make them white. Add the man's arms after you've finished his shirt, and then paint his apron using values 7, 3 and 1 of green.

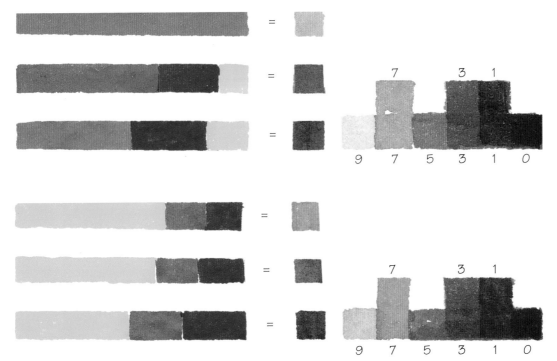

Proportion of pigments used to mix the values of the man's shirt and apron.

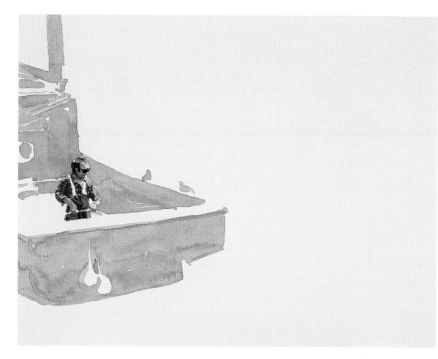

Step 3

For the white boat the man is standing on, use value 3 to paint the boat's planes, shade and perspective. Since the boat's natural hue is pure white—value 5 on a light value scale for white—you will paint around some of the areas. (You'll also paint around areas that will be painted with other colors.) The high-value edge of the boat will not show until the water is painted.

Also use value 3 to begin the shapes of two sea gulls resting on the side of the boat.

Proportion of pigments used to mix the values of the boat for steps 3 and 4.

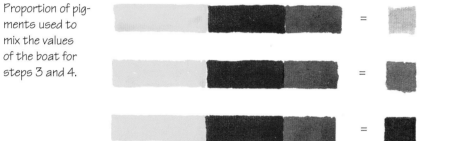

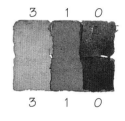

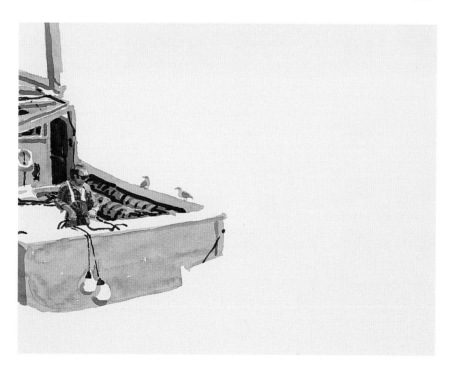

Step 4

Use values 1 and 0 to complete the shading and details of the white boat. Also use value 1 to add the sea gulls' wings.

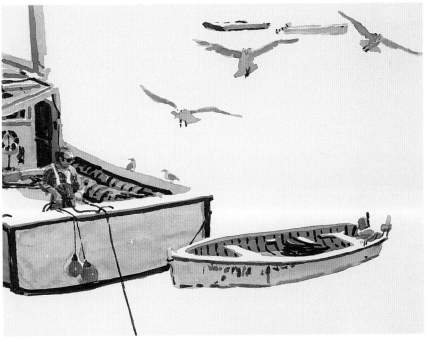

Step 5

Paint the second smaller boat using the same colors as for the big boat. To improve the composition, add flying sea gulls using values 3 and 1. (Also add some sea gulls to the small boat using values 3 and 1 of the previous step.) Add other details—including the background boat and dock, the trim on the foreground boats and the objects on the large boat—using your own choice of colors. Remember, the colors don't have to match the reference photo perfectly; interpret the colors as you see them.

Proportion of pigments used to mix the values of the flying sea gulls.

Step 6

Begin the water by painting a wash of blue in value 9. I decided I wanted to include a shore in the background, so I left a thin horizontal line free of paint at the top.

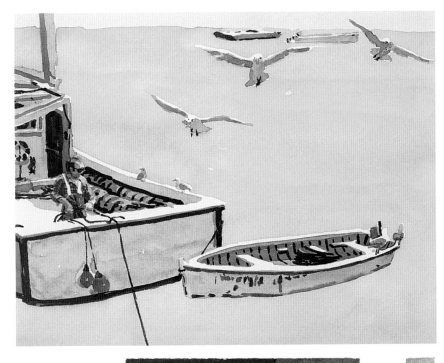

Proportion of pigments used to mix value 9 of the wash used for the water.

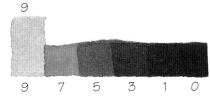

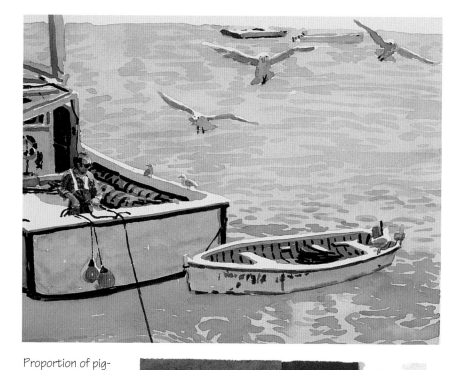

Step 7

Use the value scale below to determine the brightness or darkness of the blue you see in the water in the reference photo. Paint what you see using values 9 and 7.

Proportion of pigments used to mix the light and dark reflections in the water for steps 7 and 8.

Step 8

Use value 1 to add the darker reflections in the water and the areas shaded by the foreground boats.

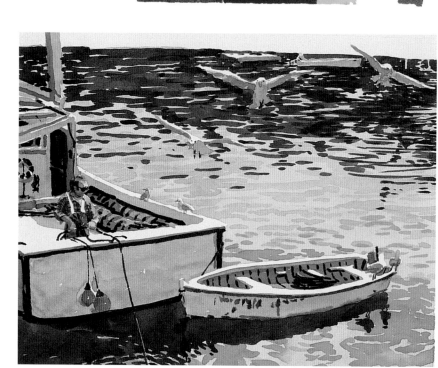

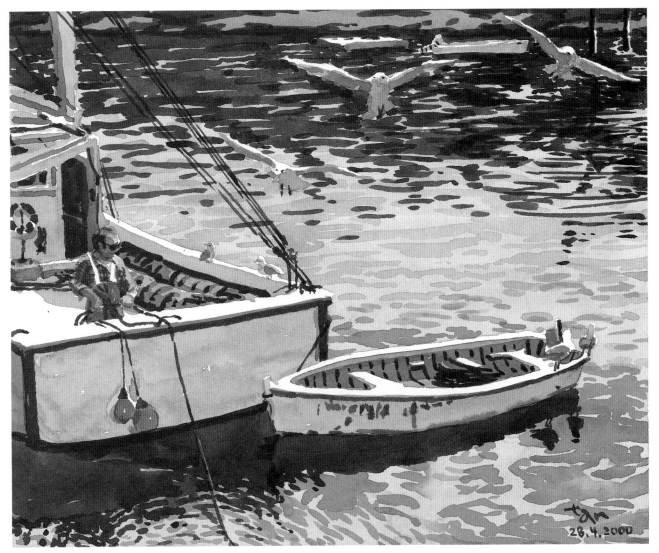

Step 9
Add a shore in the background using values 7, 3 and 1. This will
require some imagination since it is an addition not shown on the
reference photo. Just paint what you see in your mind, and remem-
ber that it doesn't have to be perfect.

Proportion of pig-
ments used to
mix the values of
the shore.

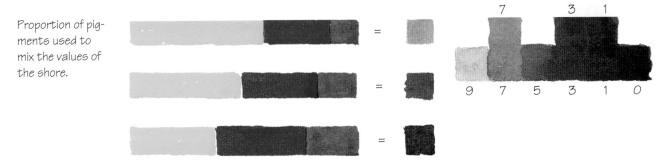

Step by Step: Landscape

I started this painting with the pink flower shapes because it is easier to see and paint the green around them than the other way around. Keep in mind that at the beginning of any painting, there is nothing much to look at, and you shouldn't consider starting over just because you have made a few mistakes in shapes or in light values. First of all, wrong shapes do not mean you are going to have a bad painting in the end. Secondly, you have to learn to complete a painting to a harmonious whole. You should make a point of finishing every painting you start. Only when a painting is finished can you accurately evaluate it.

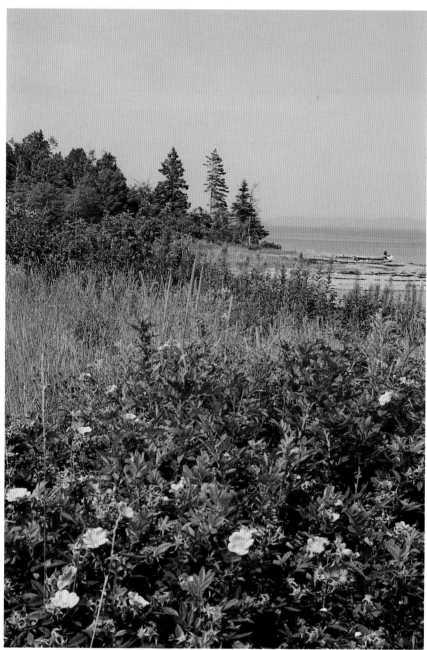

REFERENCE PHOTO
This landscape may seem complex, but it is just a collection of light values and shapes as with any other subject you paint.

Step 1
Place the pink flower shapes using values 5 and 3.

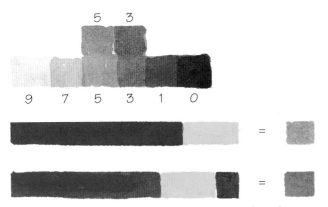

Proportion of pigments used to mix the values of the flowers.

Step 2
Paint the yellow centers and ochre shapes before the greens. Use your own judgment on the colors; it doesn't have to be perfect.

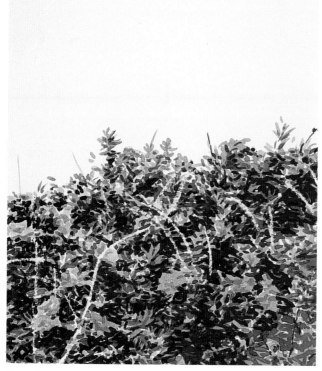

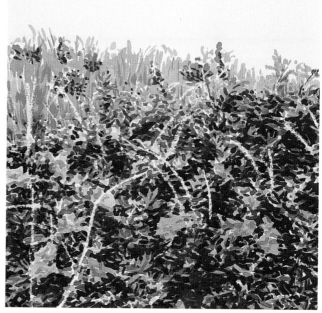

Step 3

Cover the entire foreground with green in value 7 to begin the foliage, painting around the pink flowers. Then use values 3 and 1 to create the leaves. Use negative painting to indicate tall, random, lighter stems throughout.

Step 4

Paint the middle-ground grasses using values 7 and 5, and begin the fireweed leaves with 7 and 3.

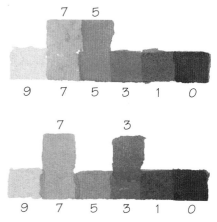

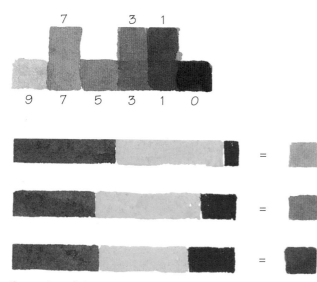

Proportion of pigments used to mix the values of the green foliage in the foreground.

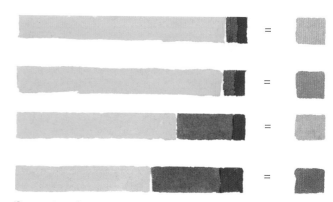

Proportion of pigments used to mix the values of the middle-ground grasses and leaves of the fireweed.

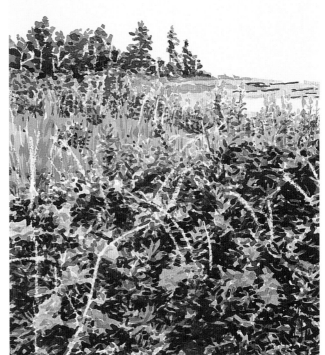

Step 5

Paint the fireweed using value 7. Since these pink shapes are small, a high value is used so they don't get lost in the painting. It is best to place the fireweed before adding more of the fireweed leaves, to make sure there will be space for them.

Step 6

Now focus on the background. Paint the beach using values 7 and 1, and the trees with 7 and 3.

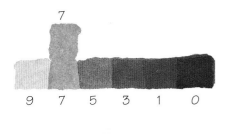

Proportion of pigments used to mix the value of the middle-ground fireweed.

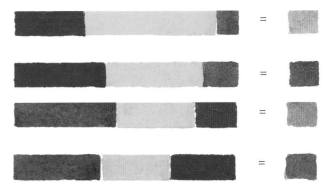

Proportion of pigments used to mix the values of the beach and background trees.

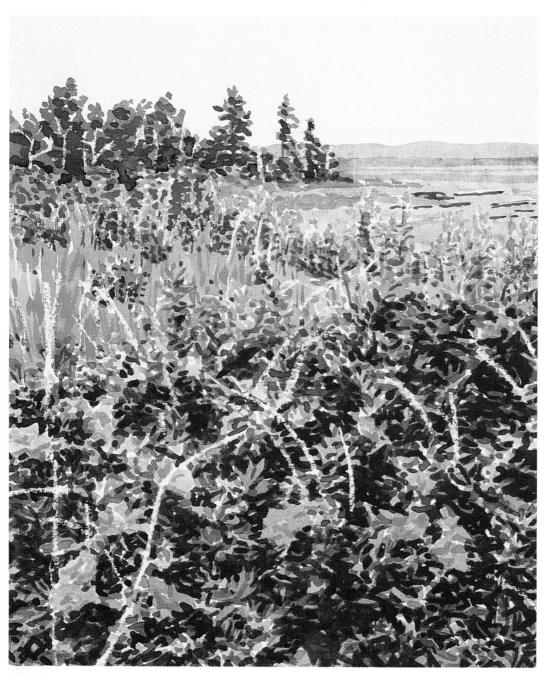

Step 7

Paint the water using values 9 and 7. Then use
grayish blue to indicate distant land.

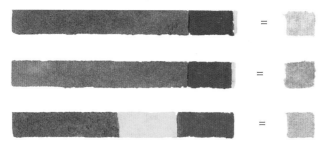

= Proportion of pig-
ments used to mix
values 9 and 7 of
the water and the
grayish blue of the
distant land.

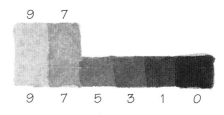

Step 8

For the top part of the sky, lay in a wash using the same value 9 that was used for the water in the previous step. To make the sky more colorful, I laid in a wash of light purple for the lower half.

Proportion of pigments used to mix the value of the lower part of the sky.

CONCLUSION

L earning to paint is not so much about learning what to do, but rather avoiding what *not* to do. This is because what you need to do is simple enough that it doesn't take much practice of seeing shapes and mixing light values in order to sharpen your perception to paint with confidence. On the other hand, the things you should avoid doing can be many—one of those things being putting too much thought into your painting instead of trusting your eye.

Having taught adult beginners for twenty-five years, I can say with absolute certainty that painting is a skill anybody with interest can learn. It has nothing to do with talent or gift. The basic instructions you need to get started are all dealt with in this book. There are more sophisticated and creative ways of using the basic elements, but they are better dealt with in another book. However, there is nothing you cannot discover for yourself if you continue to pursue your painting.

Decaying Trunk
40" × 30" (102cm × 76cm)

INDEX

MASTER THE BASICS!

Watercolor Basics: Painting from Photographs

Twelve step-by-step projects show how to spot promising painting ideas in photos and turn them into original works of art. An invaluable reference!
0-89134-893-X, paperback, 128 pages

Watercolor Basics: Painting Snow and Water

This guide addresses the unique challenges of rendering snow and water. Through eight projects you'll learn how to use basic techniques to create dramatic winter and waterscapes.
0-89134-918-9, paperback, 128 pages

Watercolor Basics: Drawing and Painting Birds

Specialized instruction for painting a wide range of bird species. Twenty-four step-by-step demos cover basic bird anatomy, beaks, feathers and more.
0-89134-919-7, paperback, 128 pages

Watercolor Basics: Trees, Mountains and Rocks

Zoltan Szabo guides you through each step of painting realistic outdoor scenery. You'll learn to mix color, create texture and set moods. Includes fifteen incredible step-by-step demonstrations.
0-89134-975-8, paperback, 128 pages

Watercolor Basics: Painting Flowers

Why stop to just smell the flowers when you can paint them? The instruction in this book makes it fun and easy to create beautiful watercolor daisies, hydrangeas, roses, lilies, poppies...all your favorite blooms!
0-89134-894-8, paperback, 128 pages